Introduction

Pinner was once a small village deep in countryside; now it is part of Greater London. It is probably more than a thousand years old, and was one of several settlements in the Manor of Harrow, a society made up of substantial yeoman farmers, small-holders, and labourers. Pinner was the largest settlement, a fact recognised by its church and its fair, both unique in the manor outside Harrow-on-the-Hill. The Lord of the Manor, the Archbishop of Canterbury, maintained three large estates in Pinner: Woodhall Manor, Headstone Manor, and Pinner Park (a deer reserve). Each of them is still distinguishable. The villagers shared the huge common fields that filled southern Pinner, but they lived near the High Street or in small hamlets, whose medieval names are still in use – West End, East End, Nower Hill, Waxwell, Pinnerwood and Hatch End – and where there are still a few timber-framed buildings. An occasional Londoner held land in Pinner.

As the eighteenth century dawned, more inhabitants had landlords with London addresses, sometimes the consequence of local people moving into London, sometimes that of outside investment. Some larger houses evolved into mansions, nearly always rented by outsiders. At the end of the century there was a daily coach to London. At the start of the nineteenth century, the modernisation of agriculture resulted in the widespread enclosure, or privatisation, of land that had been in common use. In southern Pinner, two farms were formed in the old common fields: Downs Farm in Cannon Lane and another in Rayners Lane. A third, Mill Farm, was created on the former common grazing land north of Pinner Green. Much of England's population was on the move and Pinner was on the route to London. Some people stopped in Pinner, some Pinner people moved to London, but the numbers swelled, and many small cottages appeared, mostly cheap, some made of wood.

In 1837, the London to Birmingham Railway cut across the north-east corner of Pinner, and five years later a station (now Hatch End) was opened. This direct link to London enabled those who could afford it to work in town and live in the country. An estate of fashionable villas was built in Uxbridge Road close to the station, and Pinner's first commuters arrived. But Pinner Park, now a farm, still separated that area from the centre of Pinner, and further development hung fire.

The Metropolitan Railway, which reached Pinner in 1885, changed the situation. Land close to the station rose in value and sales for development began. Now Londoners could live in the

heart of Pinner, and the area was changing, ceasing to be predominantly agricultural. Though improved farming practice required fewer workers, the increased number of inhabitants raised the demand for domestic staff, shopkeepers and assistants, building and service tradesmen, and employment was offered by the new utilities, such as water, sewage, highways, gas and, of course, the railways. Moreover, the National School, established in 1844, meant that Pinner people themselves could compete for clerical jobs in London, and they too could use the Metropolitan Railway.

By 1900, Pinner was within the orbit of London, though not yet conjoined. With the laying out of Cecil Park in that year, the Metropolitan Railway began building estates alongside its track, and its vision of Metroland began to form. In the south, a new station, Rayners Lane, was opened in 1904. North Harrow station followed in 1915. In the 1920s, landowners north and south of Rayners Lane station sold their land to construction companies, and Pinner, like so many Middlesex villages, had become part of the London conurbation by 1939. The Green Belt and golf courses preserved much open land in the north of Pinner: part of medieval Woodhall is included there; Pinner Park is a farm; the core of Headstone Manor is a recreation ground and heritage centre. A high proportion of historic buildings still stand in the former hamlets and in the High Street and surrounding nexus of old lanes, lending great charm and interest.

Pinner is a dormitory suburb whose image is defined by these green spaces and historic pockets. Nevertheless, modern times have brought three supermarkets to the old centre, artfully inserted, and many nearby shops have consequently become coffee bars, cosmopolitan restaurants and boutiques. Hatch End also has a great many restaurants, while foreign food stores are concentrated at Rayners Lane and North Harrow. It is not far to the major shopping centres of Harrow and Watford. This is the Pinner area, and these illustrations show how its places and residents have changed through time.

AROUND PINNER
THROUGH TIME
Pinner Local History Society

AMBERLEY PUBLISHING

Acknowledgements

Pinner Local History Society is grateful to its members Thamar MacIver, Michael Treisman and Graham Elcombe for compiling this book, and for taking the present-day pictures; to Patricia Clarke for contributions and support; to Hazel Gillespie, the Local History Librarian at the London Borough of Harrow, for her assistance; and to all those members of the local community who have smoothed our path in so many ways.

John and Jo Crocker have produced the map, basing it on an earlier one by the late Tony Venis.

Image Credits

N. Catford, 61b; P. Clarke, 6a, 11a, 12a, 22a, 23a, 29a, 36a, 40a, 41a, 43a, 54a, 56a, 58a, 60a, 61a, 63b, 66a, 70a, 71a, 72a, 78b, 85a; G. Elcombe, 32a, 33b, 34b, 35b, 36b, 67b, 82a, 83b, 84a, 84b, 87b, 88a, 88b, 89a, 89b, 90a, 90b, 95b; M. Hammerson, 86a; G. C. Hawkes, 77b; K. and J. Lines, 15b-1; London Borough of Harrow Local History Collection, 13a, 20a, 24a, 28b, 32b, 33a, 50a, 51a, 53a, 67a, 68a, 69a, 73a, 76a, 86b, 87a, 92a, 93a, 94a, 95a, back cover top; I. Long, 91a; T. MacIver, 6b, 10b, 11b, 12b, 13b, 15b-2, 22b, 25b, 27b, 29b, 30a, 30b, 31a, 31b, 39b-1, 49b, 55a, 56b, 57a, 57b, 58b, 59b, 60b, 62b, 64b, 65b, 66b, 68b, 69b, 70b, 71b, 72b, 74a, 74b, 75a, 75b, 76b, 78a, 79b, 81b, 85b, 91b, 92b, 93b, 96b, front cover bottom, back cover bottom; G. Manser, 39b-2; Meadow Road Jubilee Committee, 49a; F. Palmer, 47a; Pinner Association, 14b, 44b, 52a; The Sainsbury Archive, Museum of London Docklands, 21b-2; The Cottage Homes of England, by S. Dick and H. Allingham, 1909, 63a; H. Thornley, 21b-1, 45a, 46a, 54b, 59a, 79a; Transport for London, 7a; M. Treisman, 7b, 9b, 16b, 17b, 18b, 19b, 23b, 26b, 37b, 40b, 41b, 43b, 45b, 46b, 47b, 48b, 50b, 51b, 52b, 53b; M. and J. Verden, 34a, 35a; Pinner Local History Society, 8a, 8b, 9a, 10a, 14a, 15a, 16a, 17a, 18a, 19a, 20b, 21a, 24b, 25a, 26a, 27a, 28a, 37a, 38a, 38b, 39a, 42a, 44a, 48a, 55b, 62a, 64a, 65a, 73b, 77a, 80a, 80b, 81a, 82b, 83a, 94b, 96a, front cover top. (Each reference refers to the page number. A indicates the above image and B indicates the below image.)

First published 2013

Amberley Publishing
The Hill, Stroud, Gloucestershire, GL5 4EP
www.amberley-books.com

Copyright © Pinner Local History Society, 2013

The right of Pinner Local History Society to be identified as the Author of this work has been asserted in accordance with the Copyrights, Designs and Patents Act 1988.

ISBN 978 1 4456 1888 3 (print)
ISBN 978 1 4456 1867 8 (ebook)

British Library Cataloguing in Publication Data.
A catalogue record for this book is available from the British Library.

Typesetting by Amberley Publishing.
Printed in Great Britain.

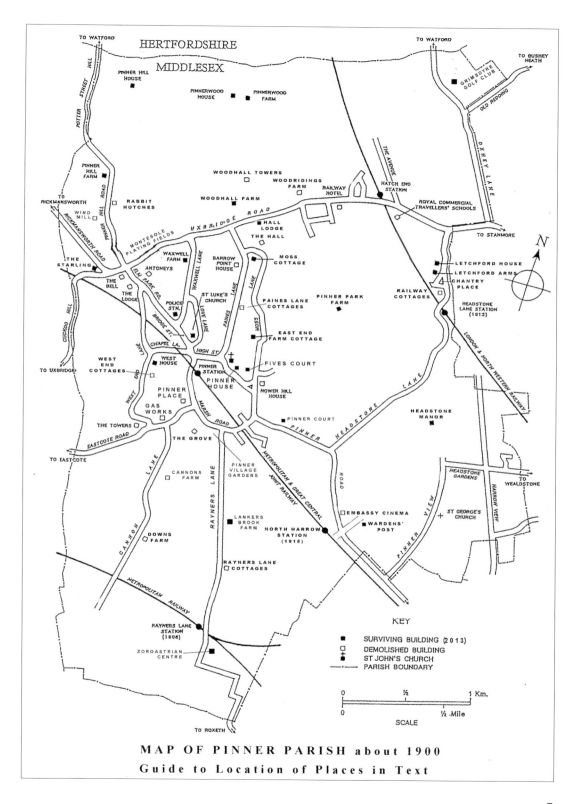

MAP OF PINNER PARISH about 1900
Guide to Location of Places in Text

KEY
- SURVIVING BUILDING (2013)
- DEMOLISHED BUILDING
- ST JOHN'S CHURCH
- PARISH BOUNDARY

SCALE
0 ½ 1 Km.
0 ½ Mile

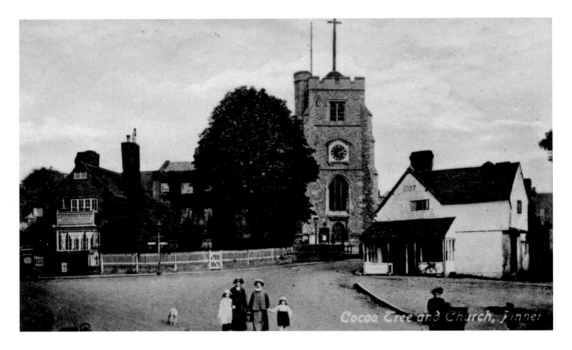

Cocoa Tree and Church, Pinner

St John's Church, c. 1904

Pinner's oldest building is its church. It was rebuilt in 1321, and its tower was added around a century later. St John's was provided to save the villagers going to St Mary's, Harrow, and only became a proper parish church in 1766. In 1801, Pinner parish (*see map*) contained only 761 people; in 1961, there were over 45,000. Though relatively few people attend services these days, there was widespread local support for the recent careful restoration of the roof and the tower. At the left was Ye Cocoa Tree, a temperance tavern created in 1878 by William Barber of Barrowpoint House. To the right, a butcher's shop occupied a house built around 1600.

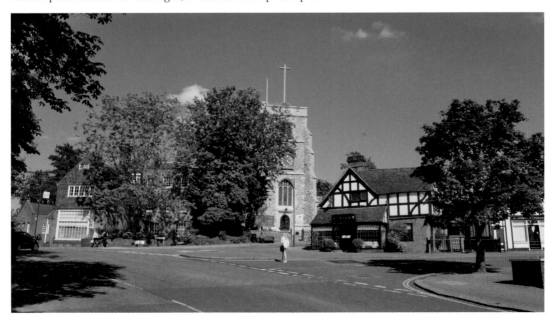

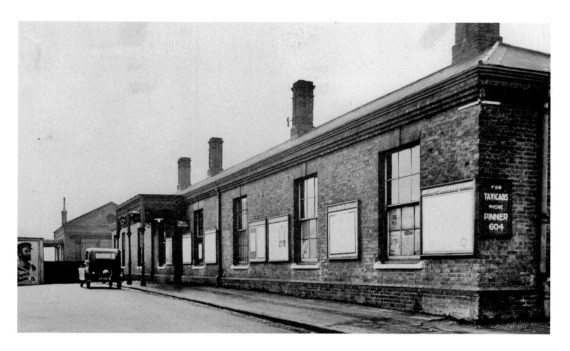

Pinner Metropolitan Station, 1934
The Metropolitan Railway reached Pinner in 1885 and the change to a residential suburb gathered pace. It was originally intended to locate the station near Cannon Lane, but the route was changed at the last moment. The proposed doubling of the tracks from two to four resulted in plans in the late 1930s, and again twenty years later, to rebuild the station with an island platform and the entrance under the Marsh Road bridge. Despite this, the station building remains, minus its tall chimney stacks, entrance canopy and the shed beyond.

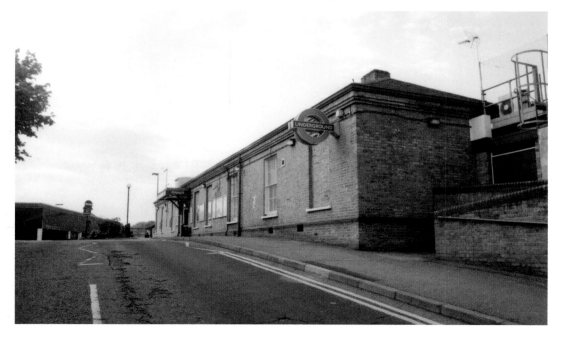

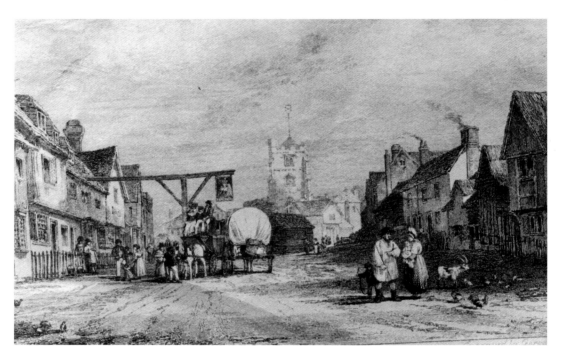

High Street: Engraving by E. W. Cooke, 1828, and Photograph, *c.* 1869
A coach ran from the Queen's Head to London in the nineteenth century. In 1828, Charles Turner was both landlord and coach driver. Nothing is known of the large barn standing at the top of the street, which had disappeared by the date of one of the earliest photographs of the High Street. Left of the church was Equestrian Villa, before it was altered to Ye Cocoa Tree. The butcher's shop at the left foreground still stands, but its neighbour, and most of the buildings beyond the weatherboarded cottage, have been transformed. The gabled house at the right was the White Hart.

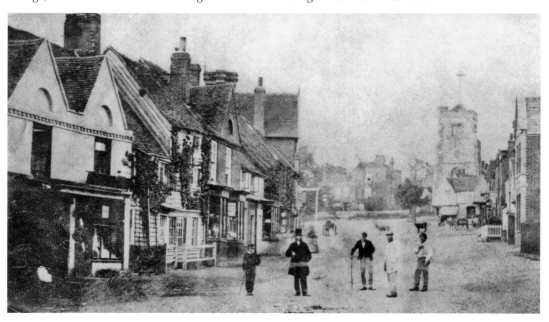

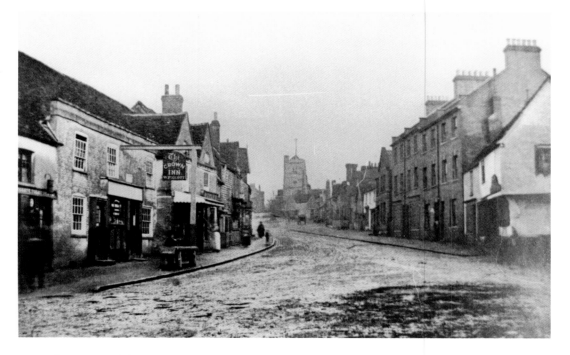

The Lower High Street, 1890s

The Crown was demolished in 1897 and replaced by Nos 1–5. The adjoining butcher's shop still has its wooden canopy. The building at the right dates from the late fifteenth century, when there was nothing between it and Marsh Road. After the Second World War, it was a pub, The Victory, but it is now a restaurant. In 1880, John Gurney built four three-storey houses in its rear garden, though they soon became shops. Barters Walk now runs through the gabled White Hart beyond.

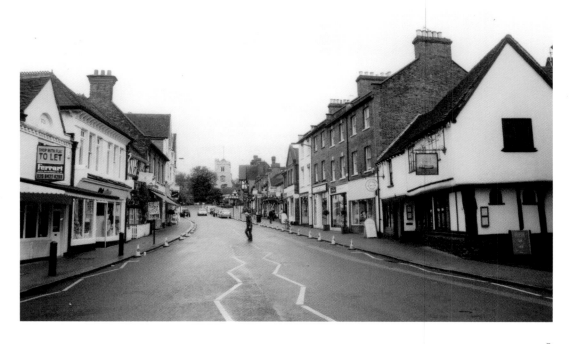

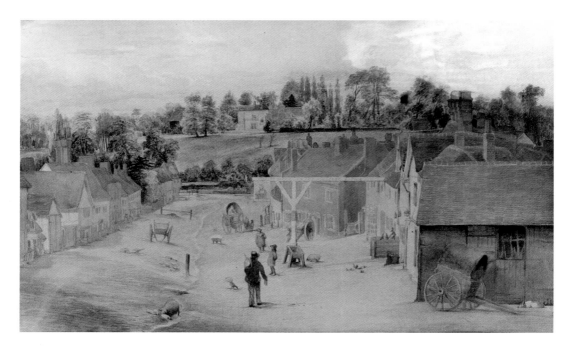

High Street: Painting, *c.* 1820, and Photograph, 1920s

A century separates these views, although West House and its grounds form the background of each. The later photograph shows few differences: at the right, the barn has been replaced by the bay-windowed shop; at the far left, the later Victory at the end no longer has its garden; the parish hall faces up the High Street, with the railway embankment behind. Kerbs and pavements have arrived – and motor cars.

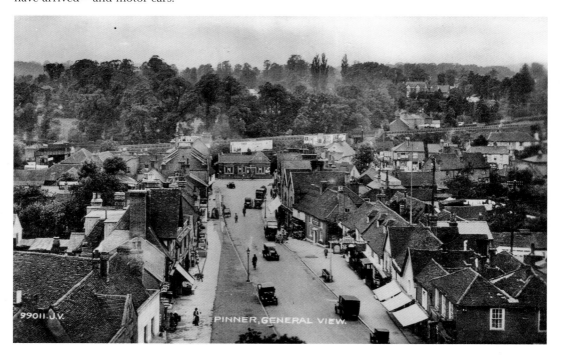

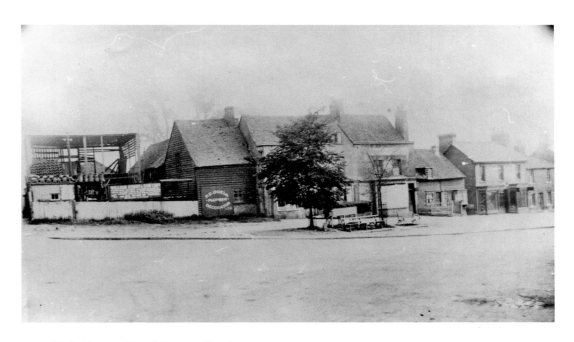

High Street: Site of Grange Court, *c.* 1920

This part of the High Street has changed completely. Grange Gardens now emerges where Ashby's timber yard and O'Dell's barn stood. There were three small shops behind the trees and then a pair of low wooden cottages. Motor engineers Gurney & Ewer occupied the bay-windowed building, and two brick cottages, known as Hedges Cottages, completed the scene. A mock-Tudor house replaced Hedges Cottages in 1927, and the matching Grange Court (*below left*) covered the rest around 1933.

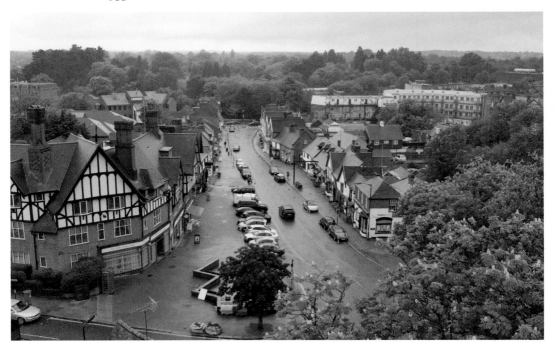

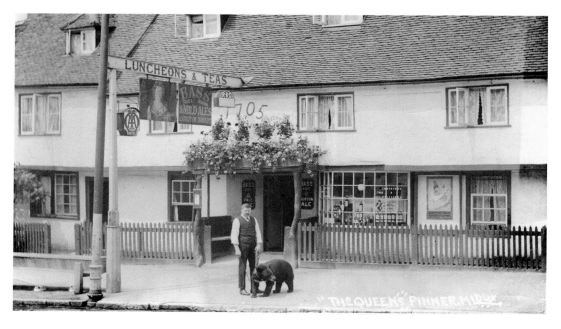

The Queen's Head, *c.* 1912

This is a mid-sixteenth-century building. It was an inn by 1636 and has so remained. Known by 1692 as The Crown, the Queen's Head acquired its present name in 1714, though it was the Upper Queen's Head from 1722 to 1766. The signpost and beam are a reminder of its coaching days. Here we see an early twentieth-century licensee, Dawson Billows, with a bear he kept briefly. His name is inscribed in a beam over the bar. The modern picture shows landlady Jill Tindall with her dog. The old timbering was exposed and added to around 1930.

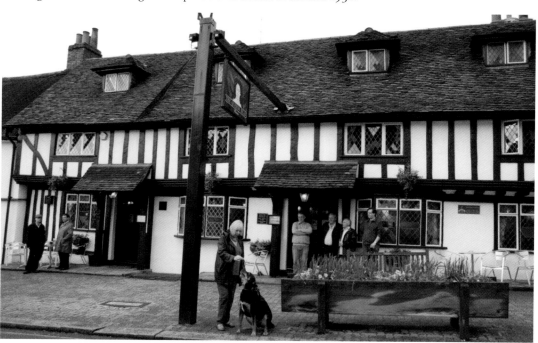

No. 11 High Street (Friends Restaurant)
Jimmy Bedford, tailor and sexton, spent all of his eighty-six years in this early sixteenth-century house. Here is his sister, Mrs Manning, dressed for his funeral in 1912. The owner of Moss Cottage, having recently bought the freehold to save the building, had the wooden cladding removed, exposing the framing. Edwin Ware, Bedford's successor as parish clerk and Pinner's first historian, lived here for a time. Some residents remember it as the Old Oak Tearooms. Subsequently a restaurant called Friends, it has been run since 1992 by Terry Farr, pictured here.

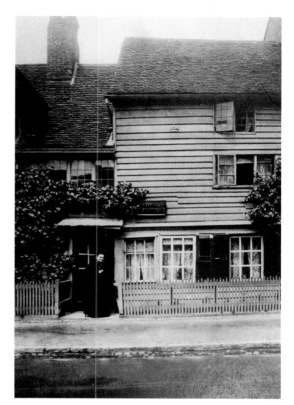

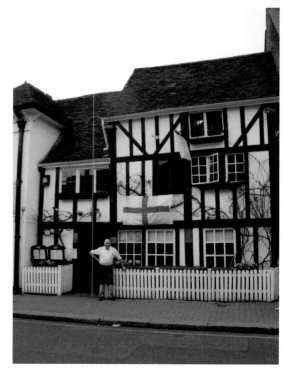

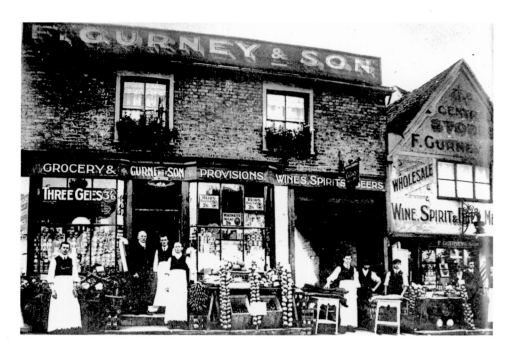

Gurneys Grocery, *c.* 1900, and Pulfords Greengrocery, *c.* 1908

It was in the High Street that routine shopping was done, and great care and pride went into some window displays. In Edwardian times, Frederick Gurney's grocery shop and wine store occupied today's Prezzo and Hand in Hand Wine bar (Nos 36–38). Below is Pulford's 1908 Christmas display of fruit and vegetables. The shop is now the hairdresser Visage (No. 25). Its painted brick façade disguises a much earlier, timber-framed building of late fifteenth-century date.

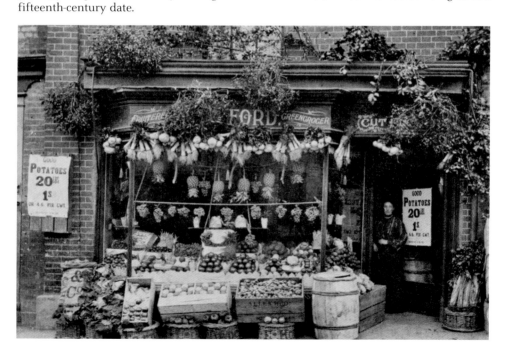

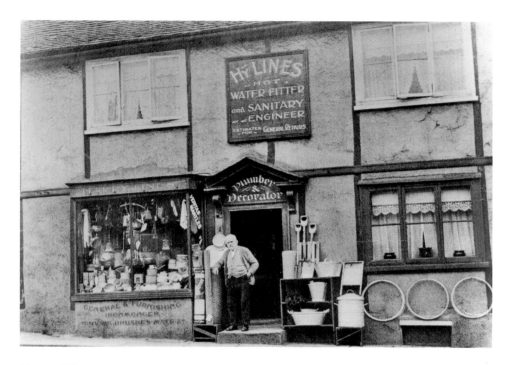

Lines of Pinner

Plumber Harry Lines had come to Pinner by 1871. He soon set up shop at No. 26 High Street, and in 1883 expanded to No. 34, now David Charles, where this picture shows him a century or so ago. Those below are his son Alfred and his great-great-grandchildren Kara and Jared outside the present shop, still at No. 26. The family's focus has shifted from prosaic hardware and plumbing supplies to designer wallpapers and furnishing fabrics, plus an upstairs gallery with William Morris wallpaper, displaying local art.

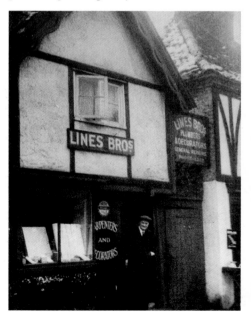

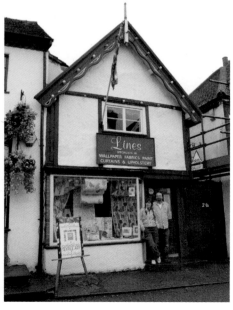

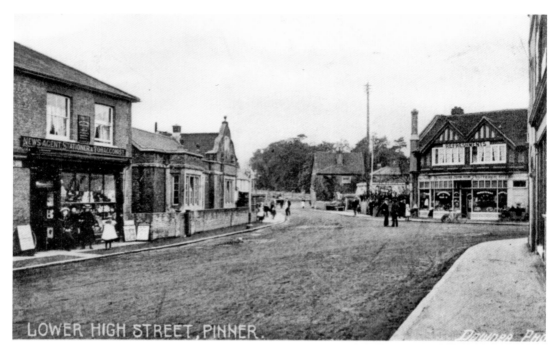

LOWER HIGH STREET, PINNER.

Marsh Road: the Parish Hall, *c.* 1900, and Bridge Street Gardens
The single-storey building facing up the High Street was the village school from 1841 to 1866, when it became the parish hall. The later nineteenth-century shops to the left hide the date '1841' on its end wall. They were pulled down in the 1930s. In 1946, the parish hall became the library. It was demolished in 1966, and the whole site is now part of Bridge Street Gardens. Over the bridge are Bridge House and then the grounds and wall of Howard Place.

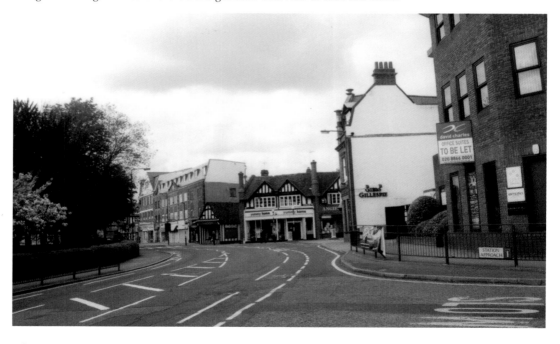

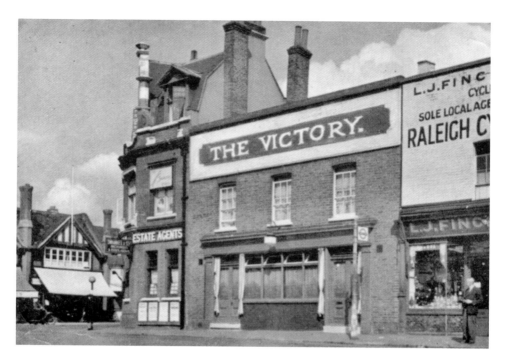

Marsh Road: The Victory, 1949, and Junction of Station Approach, 1978
The Victory and adjoining shops were built by John Gurney just before 1860. The Victory is thought to have been named in celebration of victory in a lawsuit. The licence was transferred to the building in the High Street in the 1950s, and the old premises demolished. The cottage at the right in the lower picture was Vine Cottage, also built by Gurney. Together with a number of single-storey kiosks and John Gurney's shops, it was swept away for the construction of the new Sainsbury's in 1985.

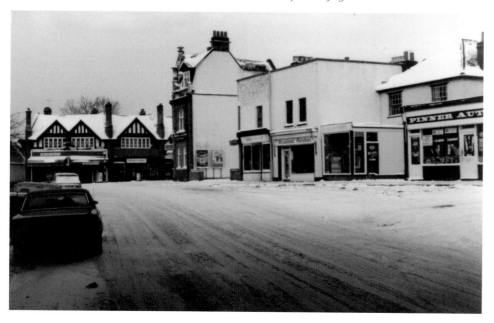

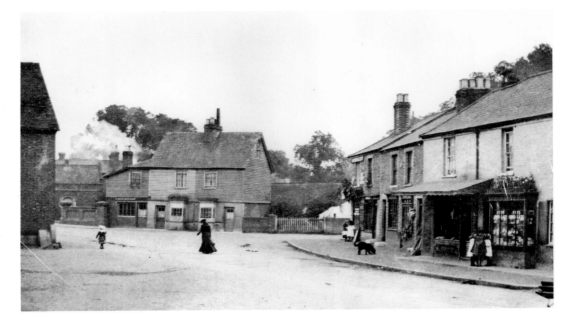

Bridge Street: Junction with Chapel Lane, c. 1900

The wooden cottages and shops were built around 1850. On the railway embankment behind them, steam from a passing train blows over the parish hall at their left. The cottages were demolished in 1942 and the site is now part of the Bridge Street Gardens. At the right, George Hedges' butcher's shop has a traditional wooden canopy, and children look longingly into the window of his daughter's confectioner's shop. Bridge House is at the left.

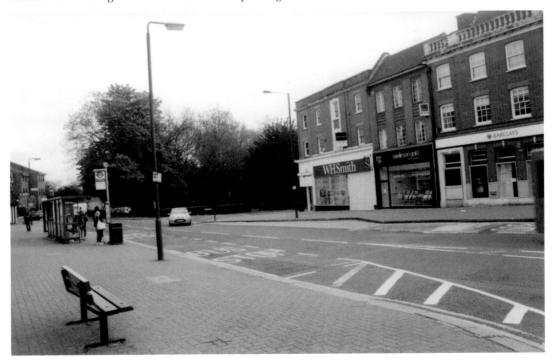

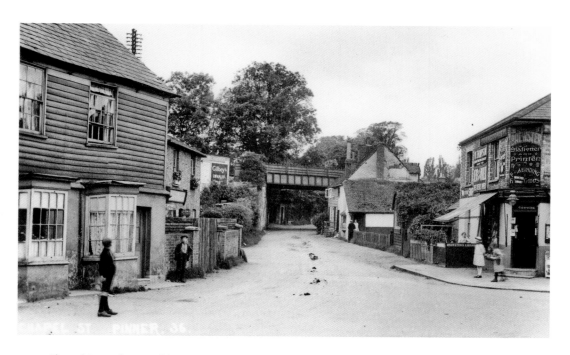

Chapel Lane from Bridge Street, 1927

All that survives from this scene is the pair of early Victorian brick cottages at the left, now extended to form Chapel Lane Chambers. The seventeenth-century cottage to the right, just by the railway bridge, was the first place of worship for the Methodists. A chapel was built the other side of it in 1844, but was demolished to make way for the bridge. The corner newsagent's was erected in 1872 by Thomas Ellement for his son John, of the old Pinner family of builders and undertakers.

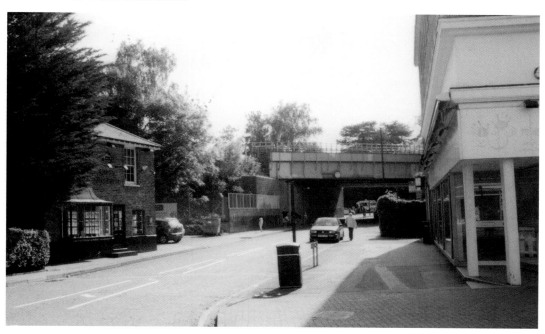

The Smithy, No. 23 Bridge Street, 1920s and 1970s

The only buildings to survive the rebuilding of the south-west of Bridge Street in the early 1930s were Nos 21 and 23, two of a row of three small cottages built very cheaply around 1806. Ellement, the undertaker, owned No. 21 and constructed the present timbered building in front. The original lasted until 1955. No. 23 housed a succession of farriers, the last being Henry Botten, who made the attractive ironwork over the door. It survived until 1989, latterly with a vegetable stall in front.

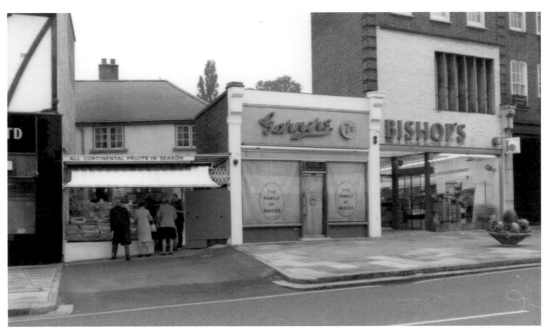

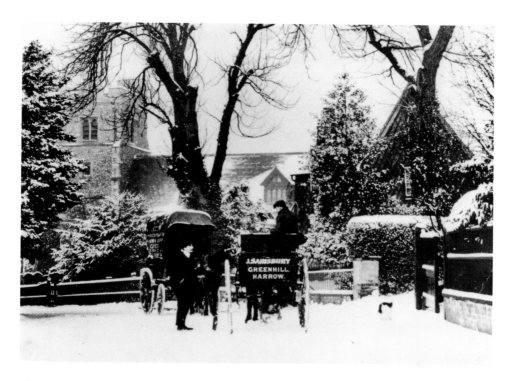

Shopping Through Time

In 1925, Sainsbury's only representation in Pinner was by this single-horse van, seen here in Church Lane delivering orders from their branch in Greenhill. But in 1933, this new parade of shops was built in Bridge Street, and Sainsbury's opened their first shop there (*centre*). That new shop had handsome tiled walls and a mosaic floor. Today, it has been replaced by a supermarket, just off the High Street. But if preferred, online orders can now be delivered directly to your home – just as they were in 1925, in Church Lane.

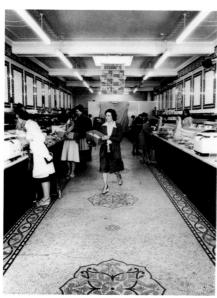

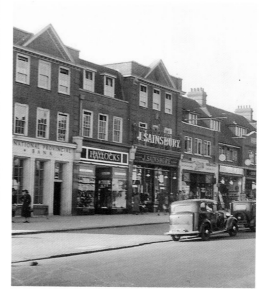

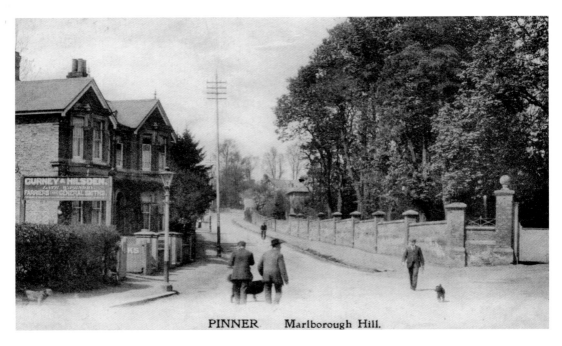

PINNER Marlborough Hill.

Bridge Street: Howard Place, *c.* 1902, and The Parade, *c.* 1914
Just visible to the right, where Love Lane joins Bridge Street, is the drive to Howard Place
(*p. 27*). The roof of Woodlands Cottage is just visible beyond the trees, with the police station
gable beyond that. On the left is the sign for the smithy at No. 23. Opposite Hedges' shops in the
lower picture, the Red Lion, which closed in 1961, can be seen at the right. Next to it is the fire
station, built in 1903 and superseded in 1937.

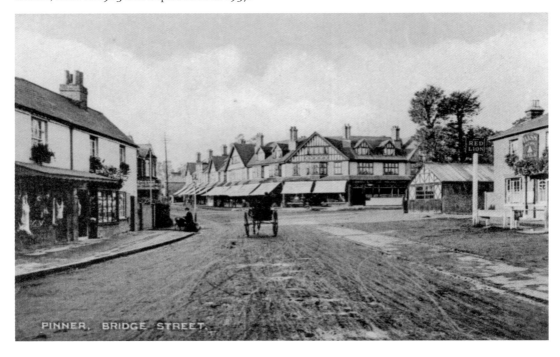

PINNER, BRIDGE STREET.

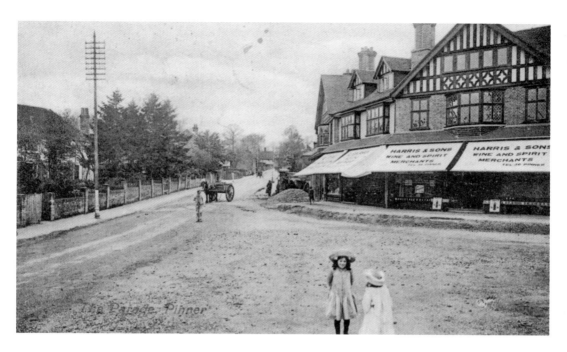

View Up Bridge Street, *c.* 1908

In 1908, The Parade was gradually extending up Bridge Street and along Love Lane, on the grounds of Howard Place. A pile of building materials lies on the pavement. Behind the trees at the left lie the eighteenth-century Fir Cottage and a few other cottages. In the distance, Dear's Farm closes the view. In the modern picture, the 1989 replacement for the smithy can be seen beside Ellements' timbered frontage.

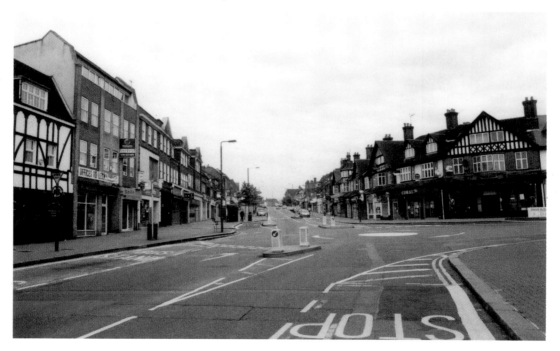

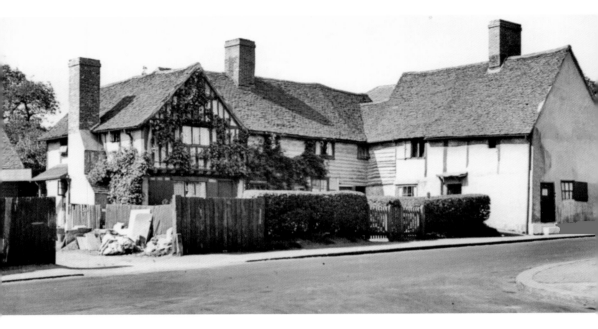

Bridge Street: Dear's Farm, 1927, and Langham Cinema, 1947

The most impressive building in Bridge Street was Dear's Farm, opposite Waxwell Lane. The left-hand side dated from the sixteenth century, the right from the seventeenth. Latterly, the property was occupied as three separate dwellings. It was sacrificed in 1935 to make way for some shops and the Langham Cinema, shown here in 1947, which had a somewhat shorter life: it was demolished in 1982 for Safeways supermarket, which is now Lidl.

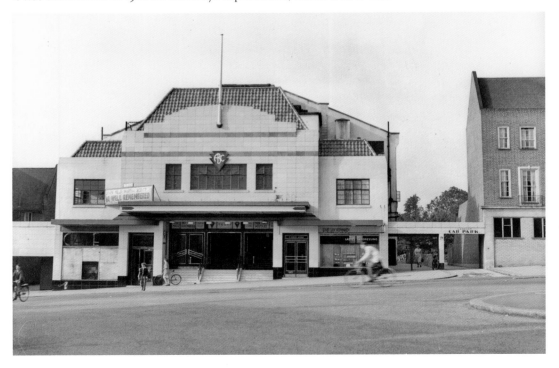

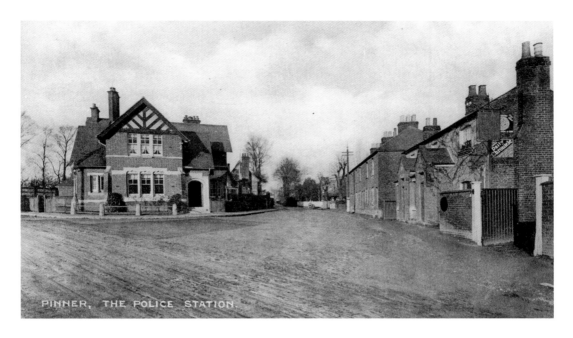

PINNER, THE POLICE STATION.

Pinner Police Station, *c.* 1914

The police station opened in May 1899, just in time to deal with a riot at Headstone Races. The station sergeant and his family lived on the first floor. The sixteenth-century Orchard Cottage can be glimpsed behind it. The Oddfellows Arms opposite, one of only two pubs now left in the village, and the brightly painted Unity Place cottages were built around 1853. With Manchester Villas (1866) just out of sight, they commemorate the Manchester Unity and Independent Order of Oddfellows, which lent money for their construction. Members paid regular contributions to the Order to cover benefits in bad times.

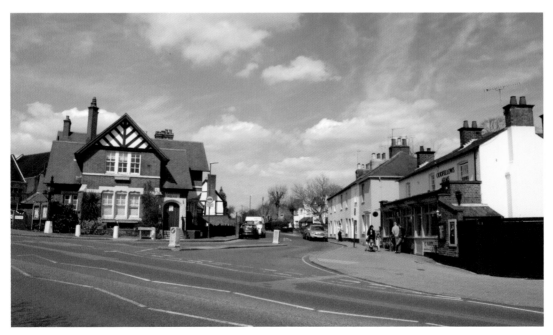

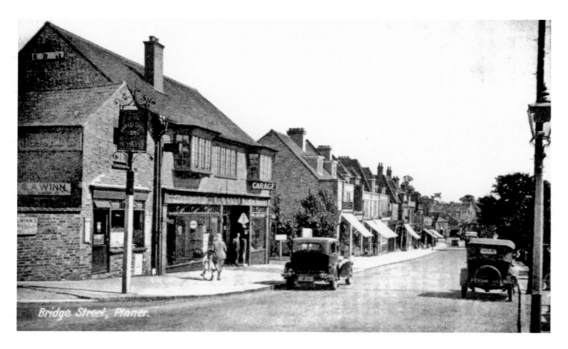

Bridge Street, Pinner.

View Down Bridge Street, 1927

The little shop on the left, which originally belonged to the Oddfellows Arms, is the only survivor from the nineteenth century in Bridge Street. Watson's Garage, then new, is now The Tyre & Exhaust Centre. Beyond it, shops stretched up from the end of The Parade almost to the garage. Note, however, the trees in the gap in between, where the three-storey shops had yet to be built. Redevelopment had not yet started at the right of the street.

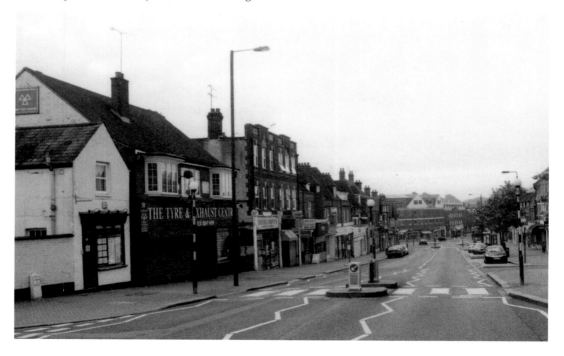

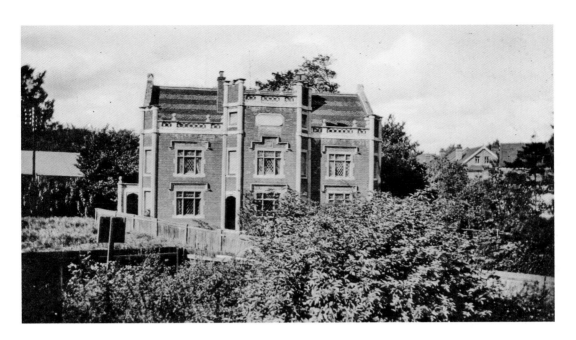

Howard Place and St Luke's Church

Charlotte Howard intended twenty-one almshouses for the widows of officers and clergymen but, after she died in 1854, her will was challenged and legal costs were such that only three were built. In 1914, part of the spacious site was bought for Pinner's first post-Reformation Catholic church, which still stands to the right of the present St Luke's. Though Howard Place, with the rest of the site, was acquired in the 1930s, the present church was not built until 1957.

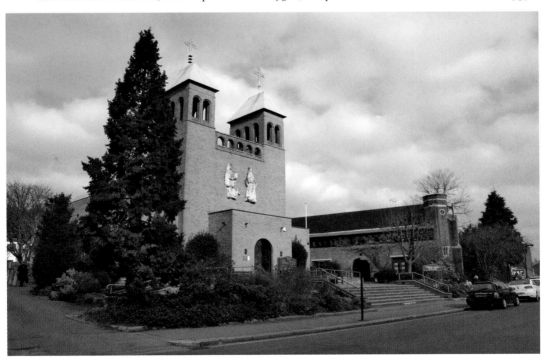

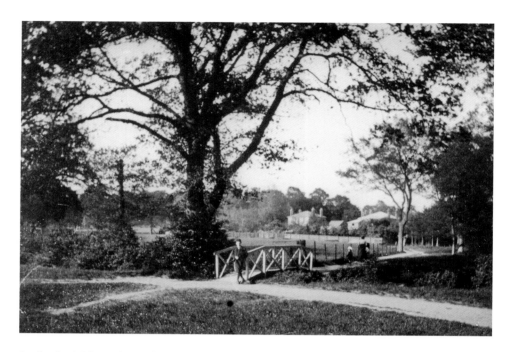

Barber's Fields and Rural Love Lane

These fields were on William Barber's Barrowpoint estate, the footpath crossing the Pinn near where Avenue Road is now. The distant houses were in Paines Lane. Barber apparently maintained the paths as a pleasant walk. Nearby Love Lane, below, sometimes called Mud Lane, remained rural until around 1900, when development began, Barber having died in 1892. In 1914, during a dispute over responsibility for the roadway, seventy-eight-year-old Crimean War veteran George Paradine said he had been born in Love Lane in 'the Clay Hut' made by his father of hurdles, furze and grass.

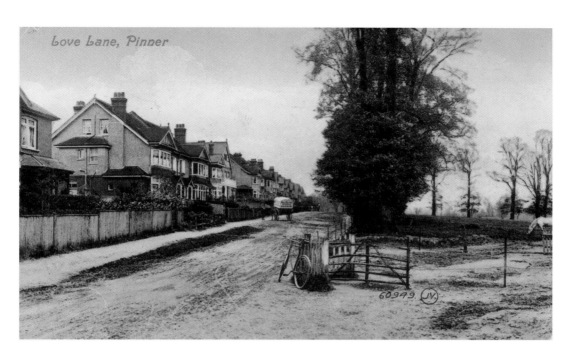

Love Lane, Pinner

Love Lane

Early residents were appalled by the state of 'Mud Lane' – they tended to take up houses during summer and its condition in winter was an unpleasant surprise. But the setting had its compensations. Alison, daughter of Thomas Heath Robinson, who lived in the lane as a child, could see across the fields to her Uncle William's house in Moss Lane beyond Paines Lane. The Methodist church moved to this site in 1918, though this part dates from 1936; its sympathetic porch of 2010 has been commended.

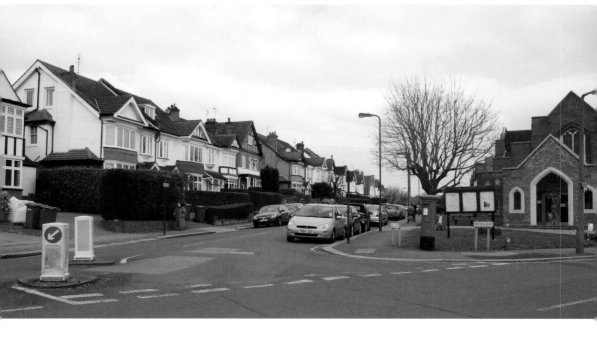

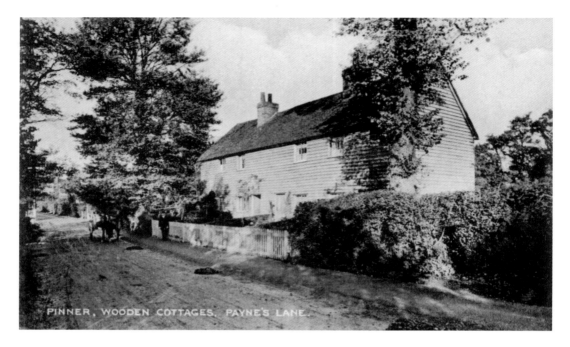

Paines Lane Near Pinn Bridge and Barrowpoint Avenue

These wooden cottages (demolished in 1939 and replaced by the houses on the right of the modern picture) in 1911 housed a coachman and his family, two laundresses, two road-cleaners and, that new phenomenon, an old-age pensioner. The white, late nineteenth-century house seen through the trees on the left in the picture below was one of those visible across Barbers' fields on page 28.

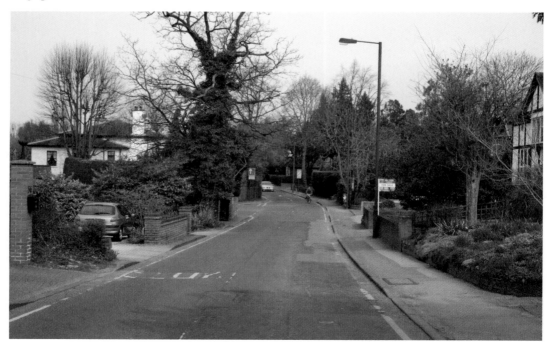

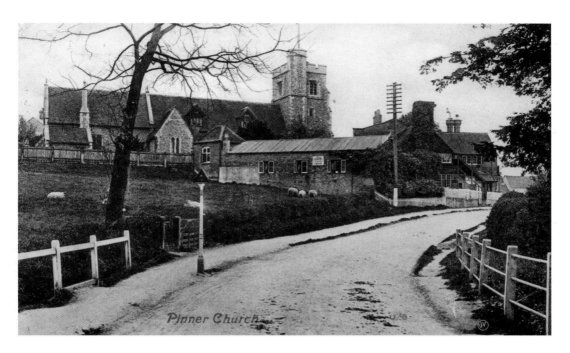

Pinner Church

Paines Lane, the High Street End

Both views are from Paines Lane, though the modern one was taken from further north, so the parish church roof, bright from its 2013 restoration, can only just be spotted above the low white wall. In the early twentieth century, there was still a shepherd in Pinner, and the white Victorian house, then bare brick, was occupied by one of the village's doctors. The Free Church was opened in 1910, ambitiously large in anticipation of population growth, replacing the little chapel by Cecil Park (*p. 40*).

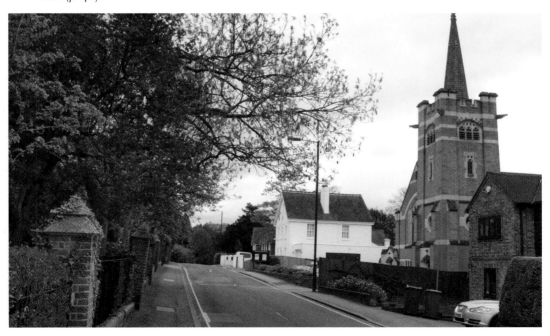

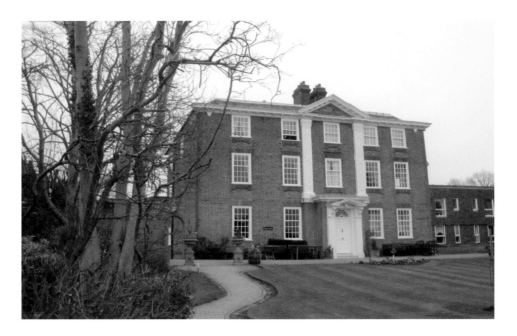

Pinner House, Church Lane

Pinner House is a seventeenth-century building that was remodelled at the beginning of the eighteenth century. From 1788 to 1810, it was the home of the Revd Walter Williams, incumbent of Pinner church. In 1947 it became an old people's home. Originally the accommodation was somewhat spartan, as these dormitories demonstrate (although the curtains, looped up in this picture, would have provided a degree of privacy). In 1978, self-contained flats for the elderly were added at the rear, some of which can be seen on the extreme right.

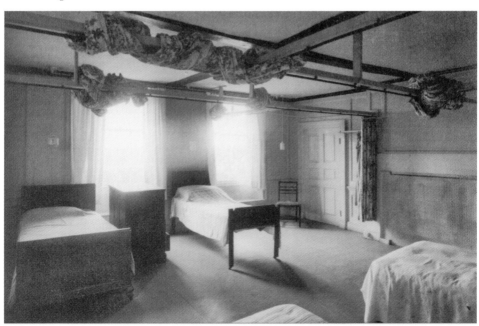

Church Lane

Apart from a television aerial and some telephone wires, Church Lane today looks almost the same as it did in 1892 (*above*). The building on the left, now Mulberry Cottage and The Bay House, dates largely from the early 1700s, as does Elmdene, originally a farmhouse, just visible in the distance. The low roof in front of Elmdene is said to have been a shelter for sheep. The timbered building at the right, The Grange Cottage, is also unchanged.

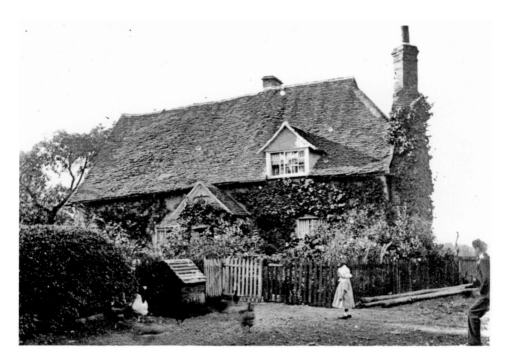

East End Farm Cottage, Off Moss Lane

One of the earliest settlements in Pinner was in the area known as East End. This cottage dates from the late 1400s. Today, the white hen and the dog kennel are no longer there, but otherwise it has changed little in the last hundred years. However, adjacent farm buildings have recently undergone a major conversion to residential use.

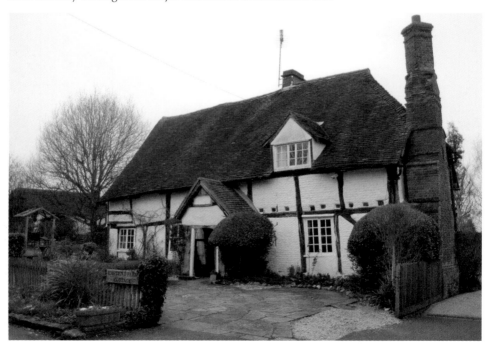

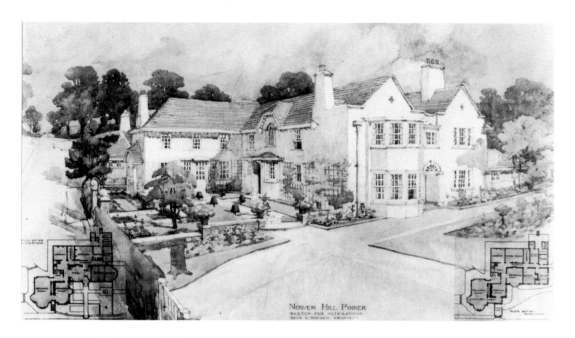

Nower Hill Pinner
SKETCH FOR ALTERATIONS
GEO. C. BREWER ARCHITECT

Nower Hill House and the Fives Court

Heal's Furniture Emporium in Tottenham Court Road opened in 1840. In the 1890s, Ambrose Heal, grandson of the founder, purchased an old farmhouse on Nower Hill, which he converted into the substantial gentleman's residence above, complete with its own billiard room. The house was demolished in 1963. In 1900, Ambrose commissioned a second house, opposite his own, for his son (another Ambrose). At the back, it included a court for playing fives. Like his father, Ambrose was a 'Furniture Designer and Retailer' as the blue plaque (*inset*) records. It is just visible on the wall below the central chimney stack.

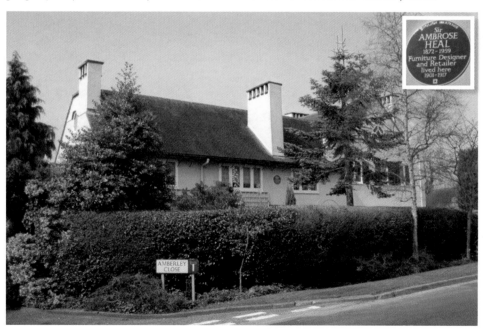

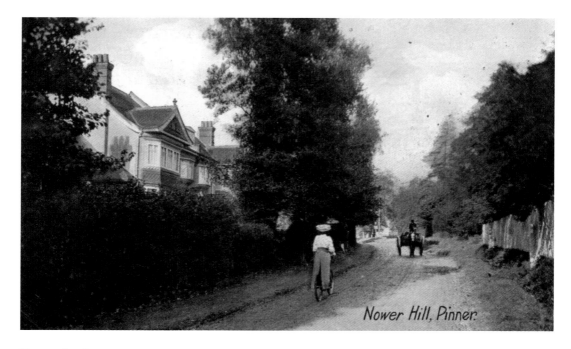

Nower Hill, Pinner.

Homes for Commuters

The coming of the Metropolitan Railway to Pinner in 1885 had made it practicable for more people working in the City to live in a village that was still semi-rural. These substantial Edwardian villas in Nower Hill were some of the first houses to be built for these commuters. Between the wars most of the new buildings in Pinner were semi-detached houses with gardens, but these handsome flats built in Pinner Road were an attractive alternative. Pinner Court is now a listed building.

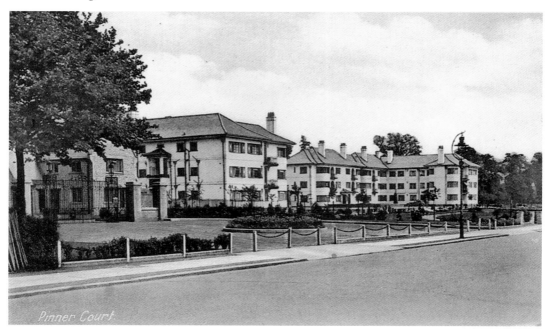

Pinner Court.

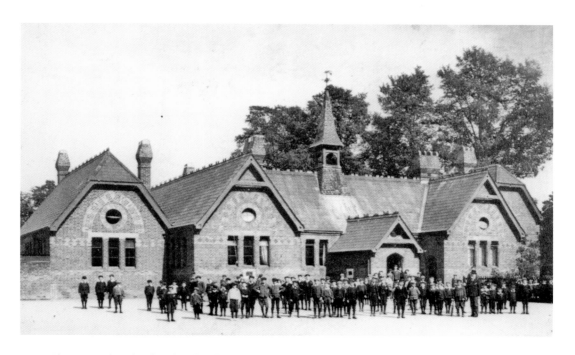

Pinner National School, School Lane, *c.* 1903
Pinner National School was rebuilt in 1866, to replace the smaller building (*p. 16*). At the right, in the bowler hat, is Charles Billows, headmaster from 1878 to 1916 and father of Dawson, (*p. 12*). The school closed in 1939 and the building was used mostly for adult learning until demolition in 1981. Weall Court, providing sheltered accommodation for the elderly, now stands on the site, named after Benjamin Weall, donor of the land on which the school was built.

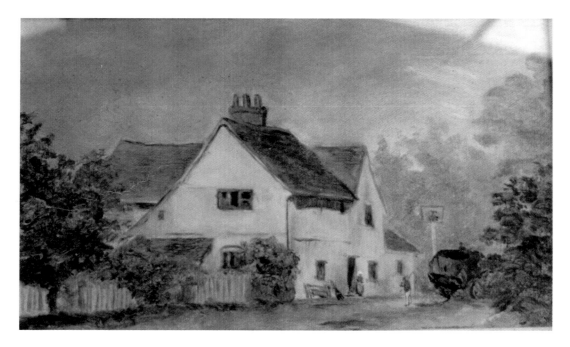

The George, c. 1880 and 1930

When this little country tavern was first licensed in 1751, its position beside the Pinn was very obvious. It was less so when Eleanor Rummens of The Grove painted it; perhaps she was unaware that it would soon be knocked down to make way for the Metropolitan Railway. It was rebuilt in 1889, with a stable at the right. Its garden beside the Pinn survived until last drinks were served early in 2013. It was demolished later in the year, despite being a locally listed building.

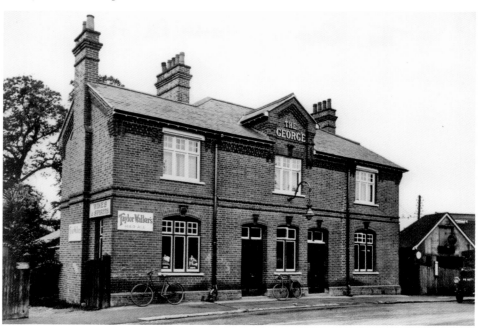

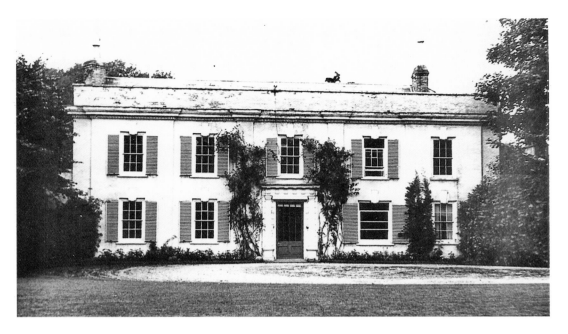

Pinner Place

The front wall of Pinner Place, facing Marsh Road across the Pinn, lay across what are now Ashridge Gardens and the footpath to West End Avenue, where its entrance lodge stood. Its grounds stretched to Eastcote Road. In the nineteenth century, it was owned by the Garrard family of Crown Jewellers; during the First World War, it was used as a convalescent hospital. In 1954, it was demolished and built over, but some of its foundations were exposed during building work at No. 16 Ashridge Gardens, at the right, in 2012.

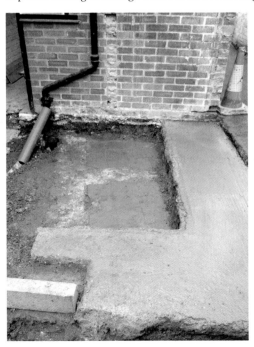

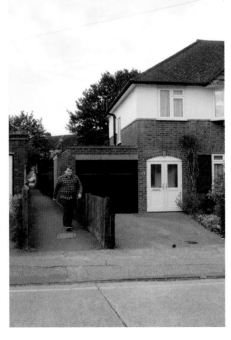

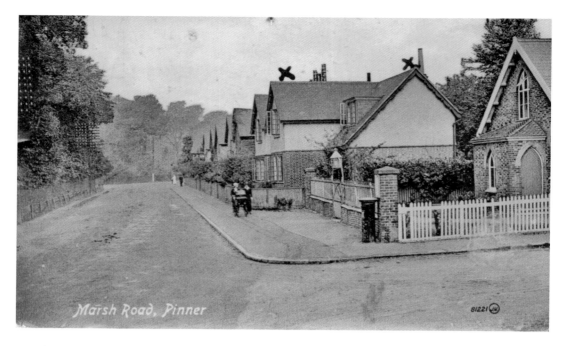

Marsh Road, Pinner

81221

Marsh Road: Stanley Villas and Baptist Chapel, *c.* 1916
The Baptist chapel in Chapel Lane was replaced by this one (*extreme right*) after the railway bridge was built in 1885. In 1910, the new church opened in Paines Lane and this building was used as the Pinner Men's Club, and then the YMCA in 1940. In 1951, it became Pinner's first synagogue. The end house was demolished when the synagogue was rebuilt in 1981. The Arts and Crafts-style houses were originally known as Stanley Villas, erected before the First World War. The trees at the left screened Pinner Place.

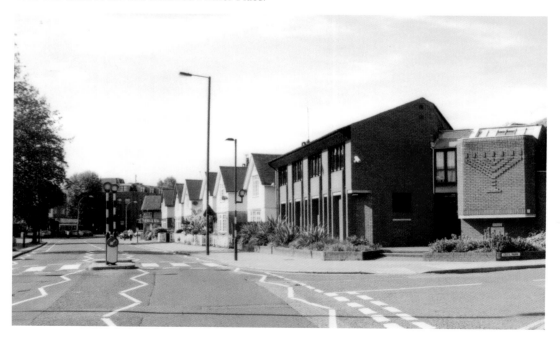

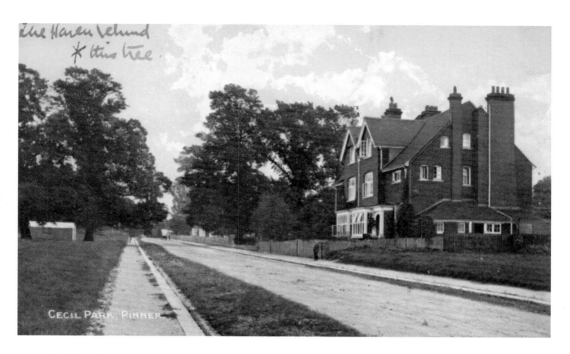

The Haven behind
* this tree.

CECIL PARK, PINNER

Cecil Park, *c.* 1901

The Metropolitan Railway Company had bought much of the land between Church Lane and Marsh Road from the Weall family for the railway, and laid out Cecil Park from 1901. It became the first of the company's 'Metroland' estates and this pair, Nos 22–24, were among the first (rather grand) houses to be built. A new wing has been added to the nearer house, but the other is largely unchanged. The estate is now part of a conservation area.

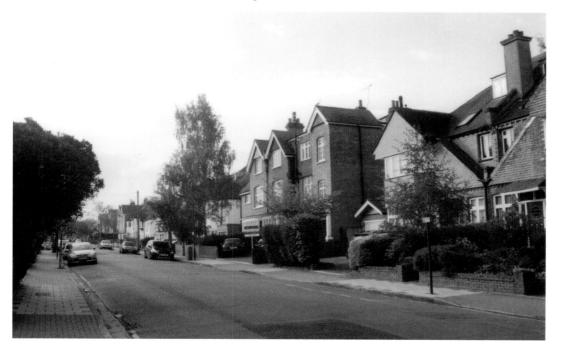

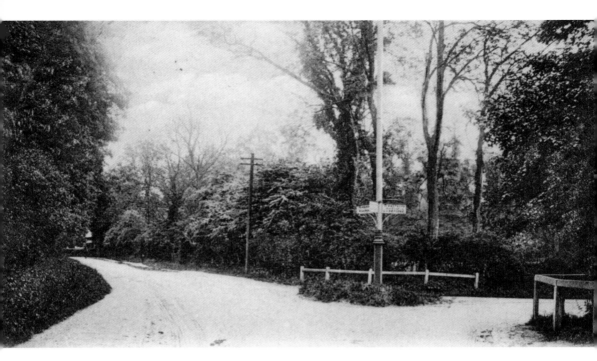

Marsh Road/Eastcote Road Junction, *c.* **1900 and** *c.* **1906**
These tranquil scenes are a far cry from today's busy junction. The trees, standing on land forming part of Cannon's Farm in the upper picture, are about to give way to five pairs of handsome, semi-detached villas built by local builder Thomas Elkington, who himself moved into the one at the far end. The telegraph post in the lower picture has acquired two horizontal bars to accommodate additional lines. The houses are little changed externally, a century later.

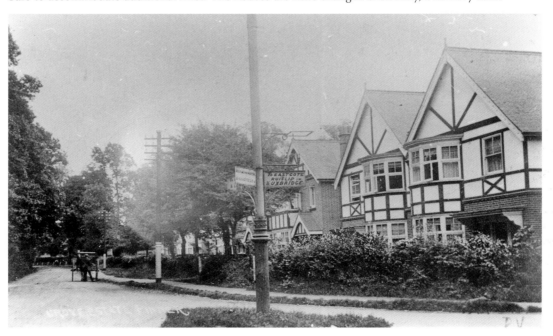

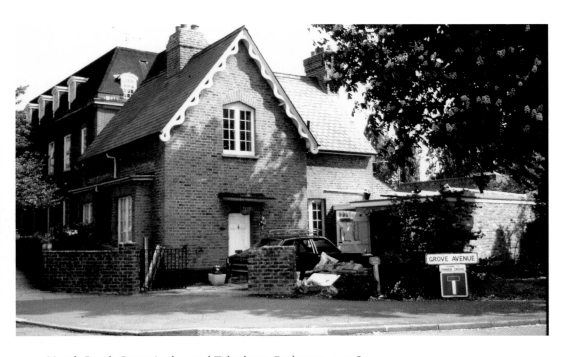

Marsh Road: Grove Lodge and Telephone Exchange, *c.* 1980
The lodge, at the corner of Marsh Road and Grove Avenue, is all that now remains of the Grove estate. It was built as two dwellings, back to back, occupied by the coachman and head gardener and their families. In this picture, it has lost its fine, mock-Elizabethan chimneys. The telephone exchange, built 1932, housed the Pinner (866) and Field End (868) exchanges, but went out of use when dials were fitted to local telephones in the early 1960s. It was recently replaced by Gray Court.

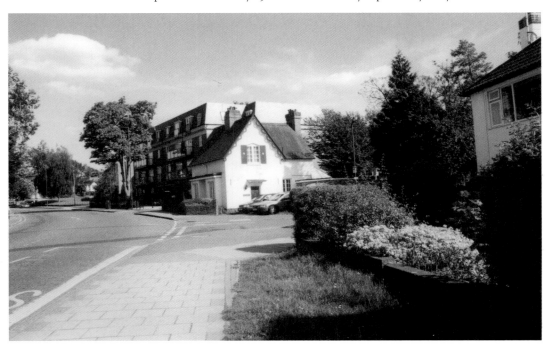

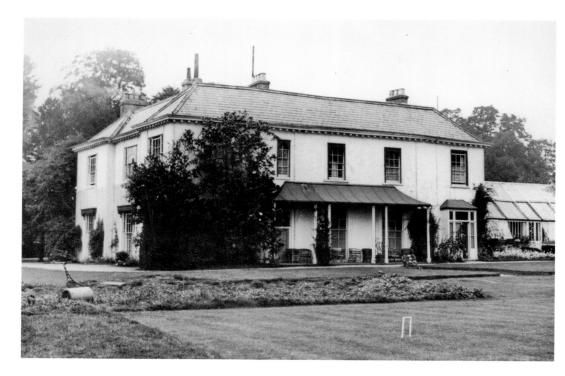

Marsh Road: The Grove Estate

The Grove boasted several eminent men among its owners: a High Court judge, Sir Michael Foster, in the nineteenth century; Sir Francis Milman, physician to Queen Charlotte; his son, Sir William Milman, Governor of the Old Bailey; and Francis Rummens, who was responsible for construction of parts of London's railways. Latterly, it was used as a nursing home. In 1949, architect C. H. James RA FRIBA exhibited at the Royal Academy this drawing of the new council estate to be built in the grounds following demolition.

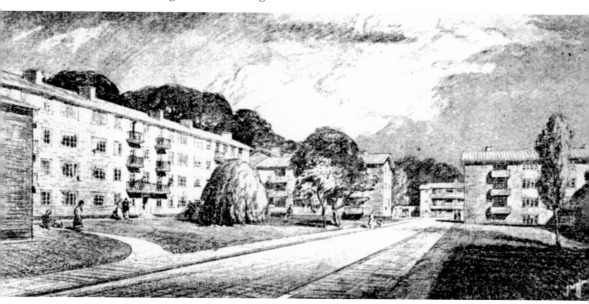

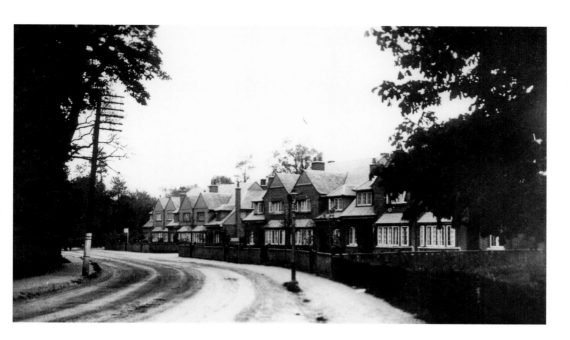

Eastcote Road Junction with Meadow Road

A freak hailstorm evidently inspired this photograph of the attractive new Arts and Crafts-style houses, probably just before the First World War. They are on the edge of the Meadow Road estate, which was erected on the former picnic ground of Ye Cocoa Tree between 1910 and 1912, by builders Milsom and Booth, for Arthur Marshall of The Towers. Architect J. E. Henderson designed both these houses and those in West End Avenue. In 2013, they are largely unaltered externally.

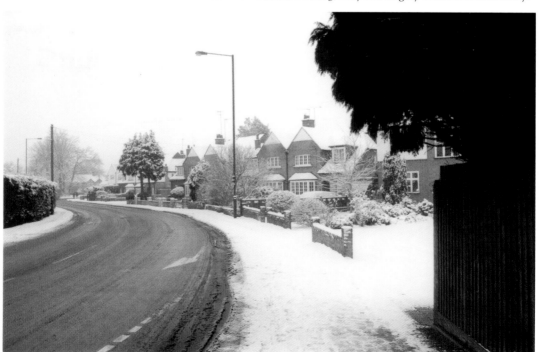

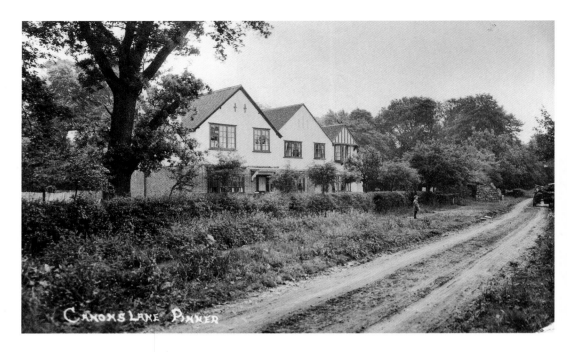

Cannon Lane, 1909

In 1909, the fields of Cannon's Farm are giving way to houses. These are the first three to be built, and are still clearly recognisable as Nos 12, 14 and 16. The pile of bricks on the verge in the distance is probably for No. 20 or No. 22, subsequently the birthplace of the late astronomer, Sir Patrick Moore. The country lane, little more than a cart track, leading only to farms, is about to become a proper road.

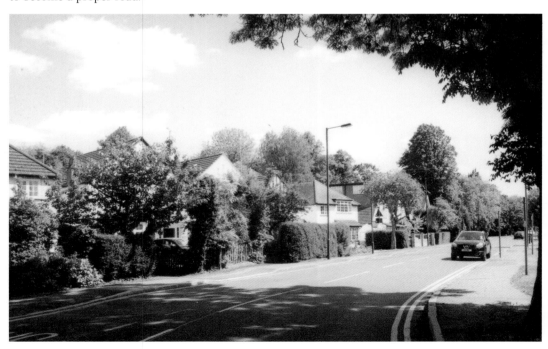

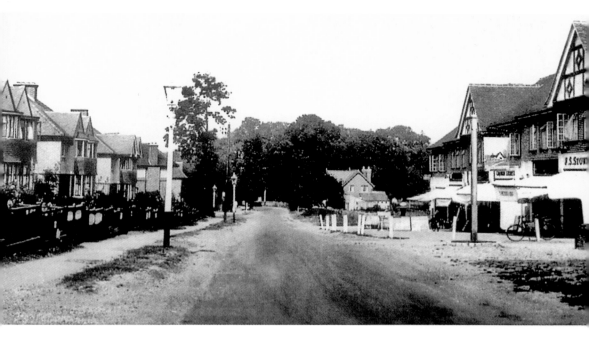

Cannon's Farm

Cannon's Farm took its name from the Cannon family, who occupied it in the fourteenth century. This was the last one, a Victorian building, nestling in the trees, shortly before demolition. An ancient barn still survives in Hereford Gardens, behind the shops. In this view of 1935–36, looking down Cannon Lane towards Eastcote Road, Lyncroft Avenue can be seen emerging from the left, but there is no sign of Whittington Way. Cannon Parade, at the extreme right, is newly built.

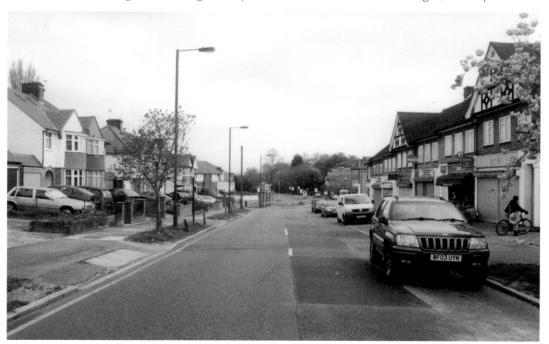

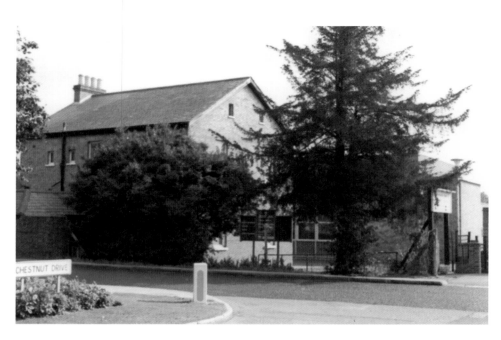

Cannon Lane: Downs Farm, 1974, and Methodist Church

Downs Farm was created around 1857 by the Prince brothers, and Cannon Lane was sometimes referred to as Princes Lane. During the 1930s, the land was largely built over. In 1956, the farmhouse and outbuildings were acquired by the Methodist church and gradually replaced, though the farmhouse survived until the early 1970s. All that now remain are the yew tree and a deviation in the line of the pavement.

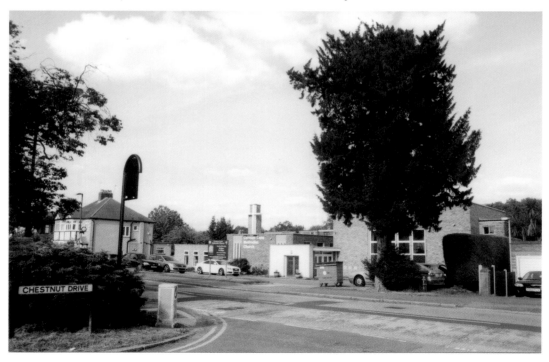

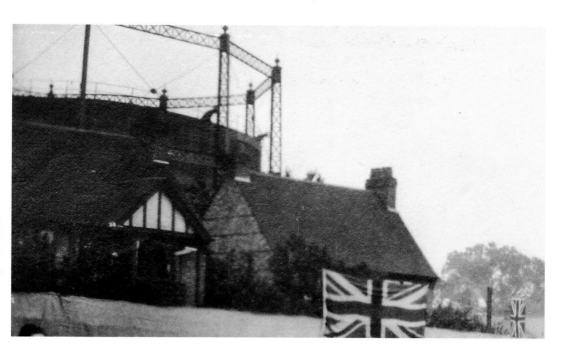

Eastcote Road: Pinner Gasworks, 1924

Pinner gasworks opened in 1864. By 1902, four gas holders supplied areas as far away as Harefield. Arthur Marshall of The Towers, nearby, was one of its chairmen. This is the only known picture of a gas-holder, looming behind Nos 41 and 43 Meadow Road; the last one was demolished in 1958, leaving only a storage depot. Below, an original wall still separates the new apartments on its site from Oak Cottages, built in 1867, whose inhabitants included numerous gas workers. Among them was stoker Thomas Rayner, of the family whose name is perpetuated in Rayners Lane. The farthest cottage was added in 1980.

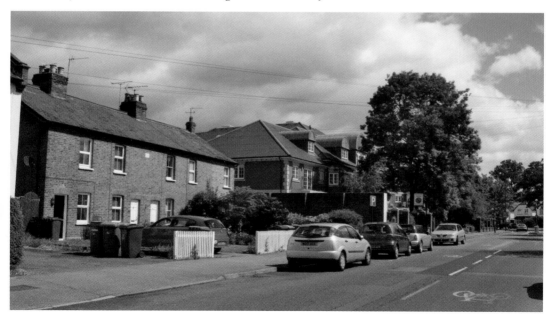

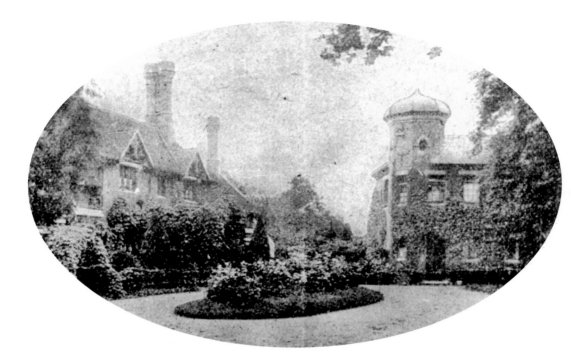

West End Lane: The Towers

Agnes Bertha Marshall, a celebrity cook of the 1890s, bought Temple Farm and converted it into a modern mansion with a towered annexe, which contained a striking clock. The Pinn flowed through the grounds and a tiny ornamental island was created in it, which still survives. Her husband Alfred became chairman of the gas company. The line of horse chestnuts and limes alongside the river, below, is a relic of the grounds on which Lloyd Court, named after the last owner, was finally completed in the 1960s.

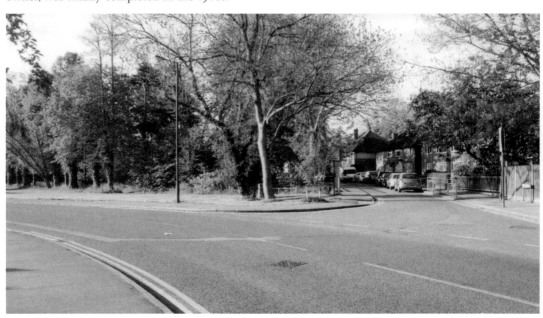

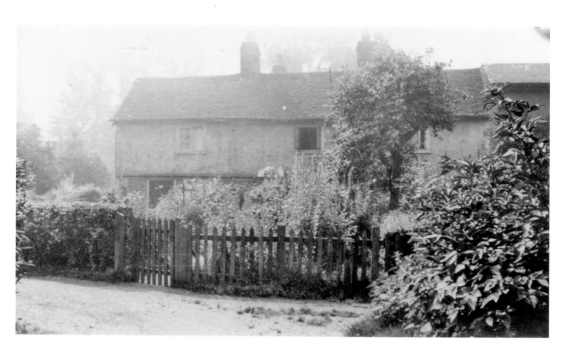

West End Lane: West End Cottages

Where Nos 16–17 Dickson Fold now stand were two terraces of three small cottages, placed back-to-back, sideways on to the road. The row facing West House (*seen here*) dated from the late eighteenth century, and those behind from the nineteenth. Mrs Manning, sister of parish clerk James Bedford (*p. 13*), and her daughter Eliza Bedford, spanned eighty-five years living in one cottage, living to ninety-one and ninety years old respectively. The cottages were declared unfit for habitation and replaced in 1951 by Dickson Fold.

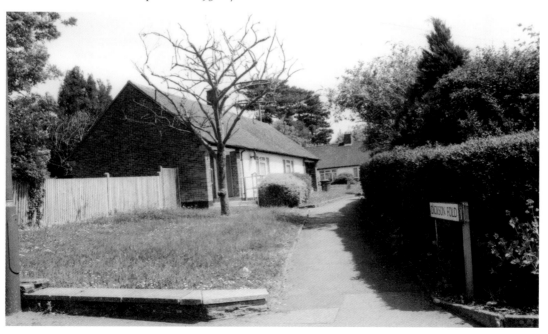

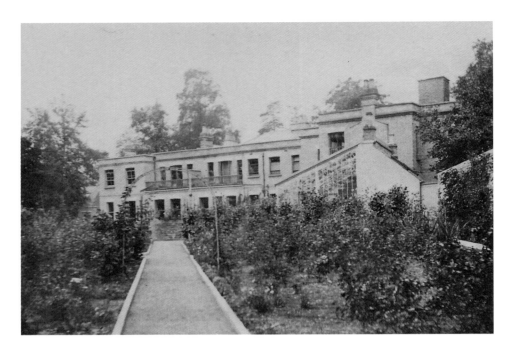

West End Lane: West House, 1888

West House is the last of Pinner's mansions to survive with its estate as an entity. It was rebuilt in the nineteenth century and this is the earliest known photograph of it. Lord Nelson's grandson, Nelson Ward, lived there from 1873 to 1883. In the late 1930s, it was purchased for redevelopment, but the war intervened and the property was used for Civil Defence purposes. After the war, the estate was purchased by public subscription as a war memorial from Cutlers, who reduced the price.

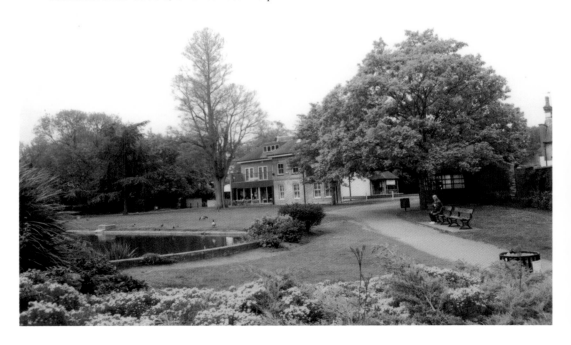

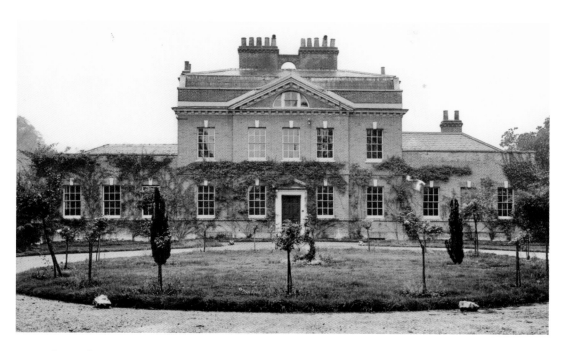

Elm Park Road: The Lodge

This elegant house dated from the mid- or late eighteenth century, and stood at the corner of Elm Park Road and West End Lane. John Zephaniah Holwell owned it from 1794 until his death in 1798 at the age of ninety-eight. He was a survivor, and the historian, of the Black Hole of Calcutta (1756), and later Governor of Bengal. The house was demolished around 1934 and Elm Park Court erected on the site.

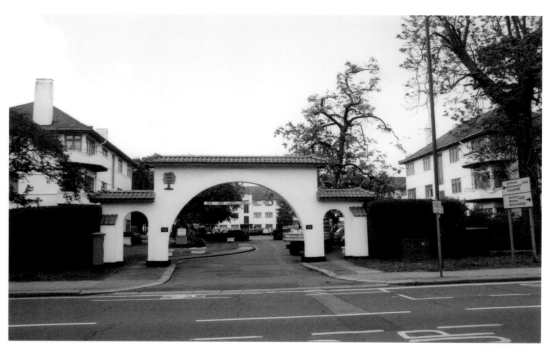

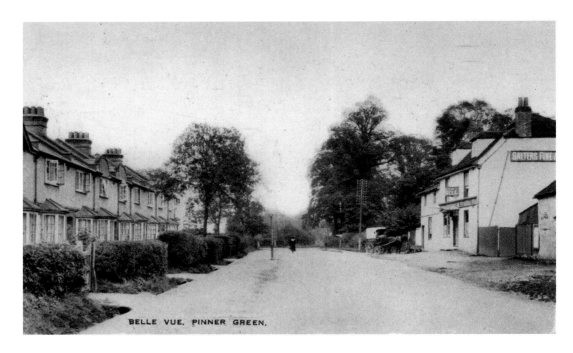

BELLE VUE, PINNER GREEN.

The Bell, Pinner Green

Two views, from opposite directions and some thirty years apart, show the same terrace of houses and two different incarnations of the Bell. There had been a still earlier Bell, further west and set back from the road, in the eighteenth century, when the land north of the road was open common. Pinner's toll house was on the north-west corner of this crossroads. The last Bell, evidently rebuilt to appeal to a motoring clientele, was demolished in 2005, like so many of these road-houses with their temptingly spacious sites.

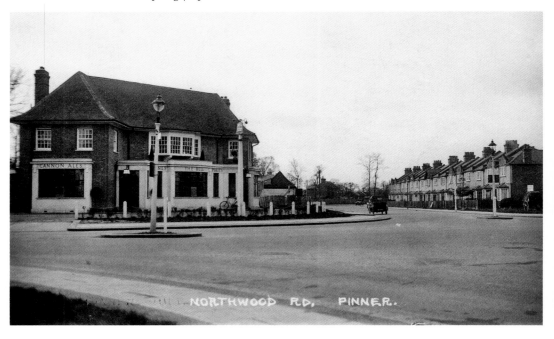

NORTHWOOD RD, PINNER.

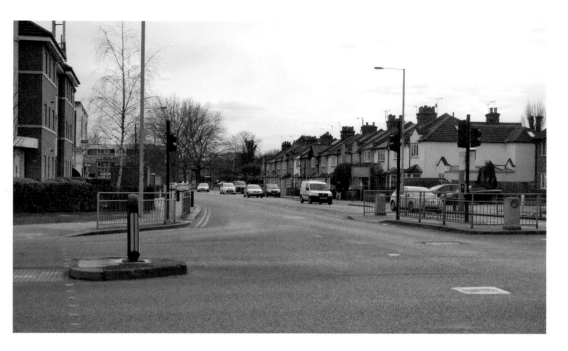

Pinner Green

Here is the crossroads today, showing the flats that replaced the Bell. Sir Frank Ree, pictured below in his garden, lived at Antoneys, east of the crossroads, now Antoneys Close. He was General Manager of the London & North Western Railway and daily took the company's horse-bus to Hatch End station. His grounds, like others in Pinner, were opened each year to locals and the LNWR horticultural show was once held at Antoneys. This photograph evokes the lost gardens of Edwardian Pinner on which so many of our homes are built.

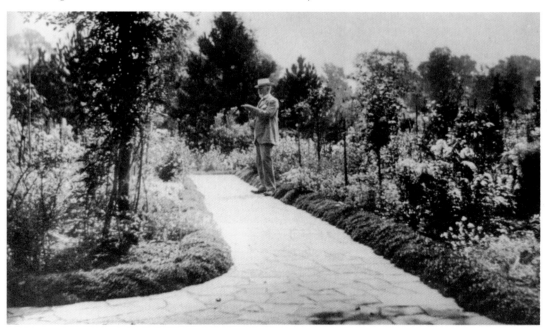

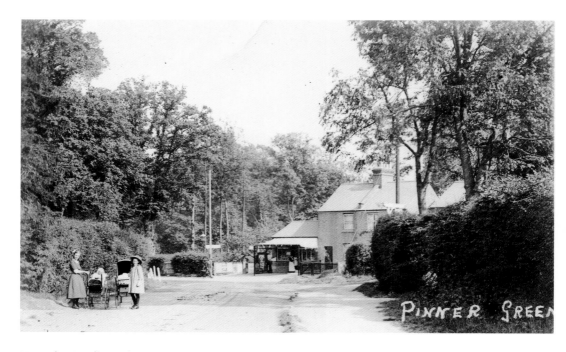

Near the Starling, Pinner Green

The same junction from two different spots. Above, the Starling is behind the hedge on the right, while the little shop seen above is behind the Tesco sign below, shuttered. The Starling originated in a beerhouse further up Cuckoo Hill around 1830. The present building dates from around 1881, like the cottages opposite it. The Starling's name is rare and unexplained. The RSPB found no other Starling among the country's 'bird pubs' in 1980, and a recent check suggests it is still unique. So the survival of name, and sign, is pleasing.

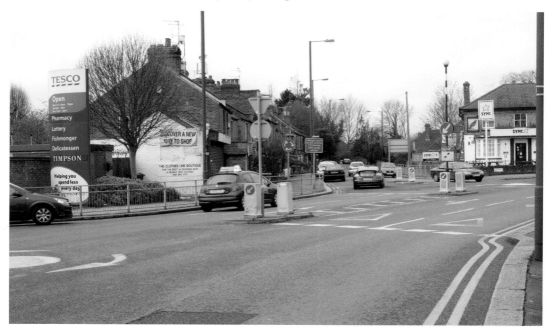

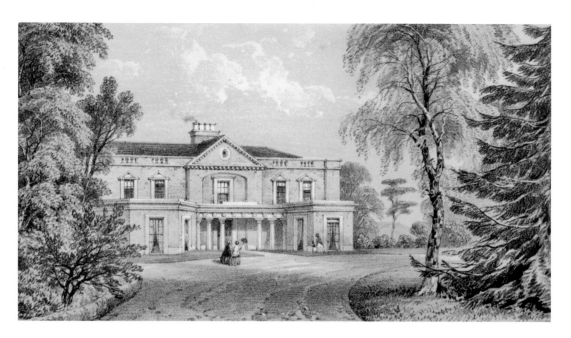

Pinner Hill House Golf Club
One of Pinner's grandest mansions and the greenness of Pinner Hill were preserved by the golf club. The print shows the front around 1850, later transformed by Arthur Tooke; the photograph shows the back on Boxing Day 2010. The golf course (crossed by a public footpath) boasts wonderful views. From the Hill, a resident watched Parliament burning in 1834, and during the Blitz, members of the Home Guard saw London on fire. Today, one can see Wembley Arch, Harrow Hill, the Kodak chimney, Canary Wharf and sometimes the London Eye.

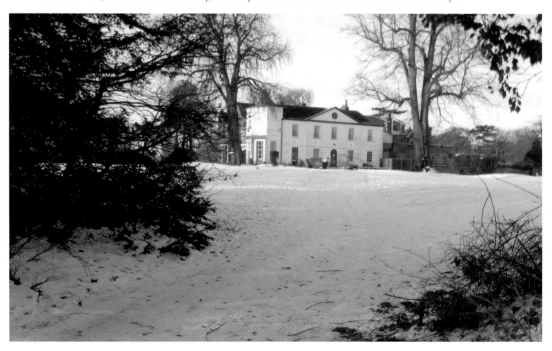

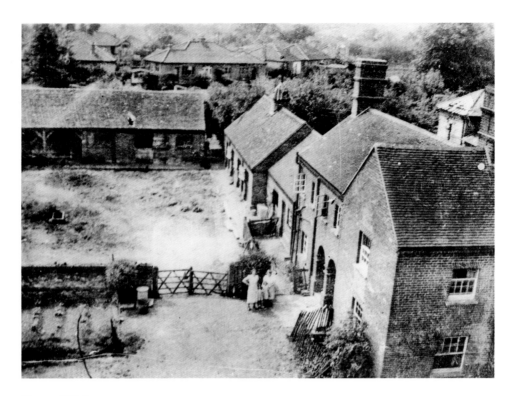

Pinner Hill Farm

Arthur Tooke, owner of Pinner Hill House, added this spectacular tower to his home farm in 1862. He also enlarged the mansion, built towers there and at Woodhall (*p. 64*), and restored the parish church. The farm remained in operation until the 1930s and was used as stabling thereafter, before being sensitively converted into homes and offices in 1985. The strange stones surrounding the farm are original sleepers from the London to Birmingham Railway through Hatch End, replaced because they made for a very bumpy ride.

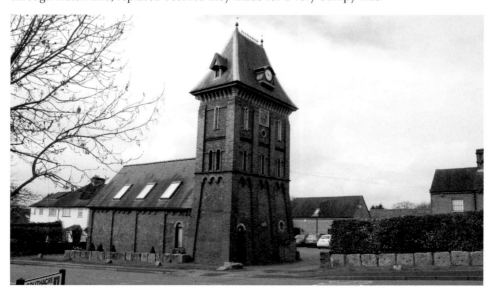

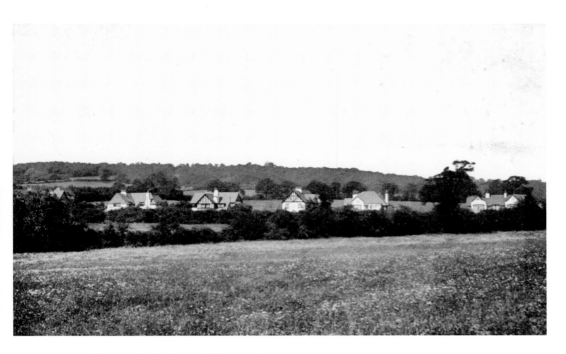

Countryside North of the Uxbridge Road

When these houses were built north of the Uxbridge Road, they were surrounded by fields. Three survive – the fourth from the right is Cloister Wood, beside Poplar Close. Now housing envelops them and the countryside can only be enjoyed in a sliver of Green Belt land further north, where the London Loop, 'the walkers' M25', passes through Pinnerwood Farm. This lower view is looking west from that path, towards Pinner Hill. Newcomers here include green parakeets.

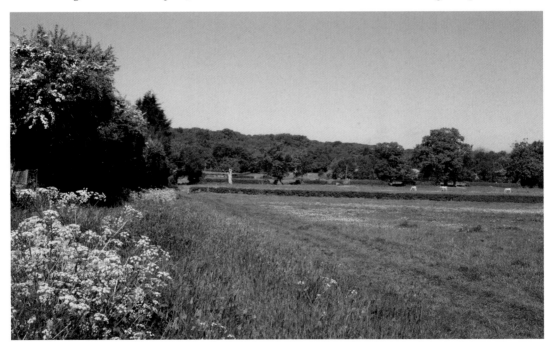

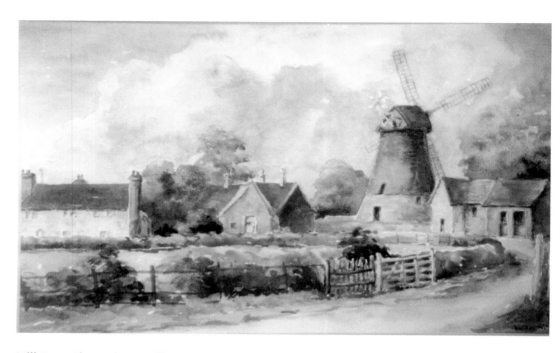

Mill Farm Close, Pinner Hill Road

The painting shows the turning from Pinner Hill Road around 1870 into what is now Mill Farm Close, shortly before the mill burnt down. A small farm developed in the surviving buildings, which lasted until the 1970s. Housing on the site has just been rebuilt as Windmill Park, visible behind the trees, including affordable housing, which would have been as welcome to the tenants of the 'Rabbit Hutches' (*see p. 61*) as it is today. This photograph was taken during this work in July 2013.

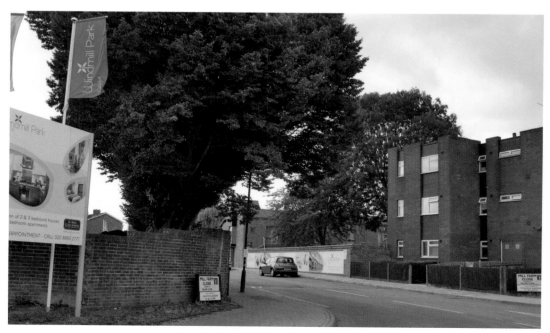

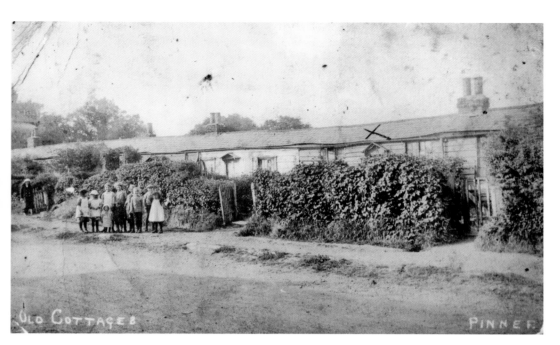

The Rabbit Hutches, Pinner Hill Road, and the Chalk Mines

Built in the 1830s, these flimsy cottages survived until 1926/27. They contained a kitchen/living room, two bedrooms and a scullery. In 1901, they were 'unfit for human habitation' though 'exceptionally clean', but councillors allowed their repair because inexpensive accommodation was scarce. There are extensive chalk workings around the top of Pinner Hill Road and underneath Grim's Dyke at Montesole Playing Fields, the most impressive being this mine, worked from 1850 to 1870. No one visits the mines now – the curse of 'Health and Safety'.

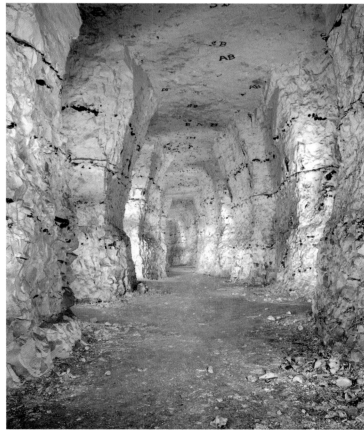

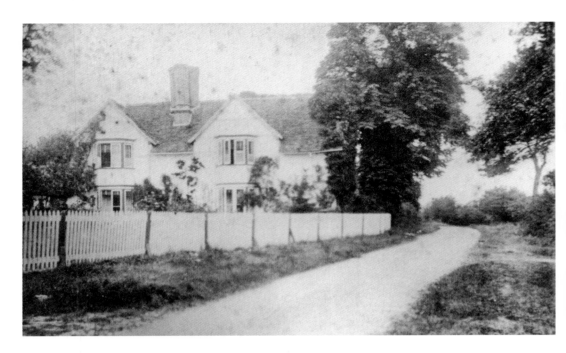

Waxwell Farm

This was a farm until the late nineteenth century. The early seventeenth-century farmhouse was significantly extended in 1895 and occupied by increasingly prosperous people; these additions can be glimpsed in the modern picture. In 1947, it was taken over by The Grail, a Roman Catholic society, who ran it until 2012, adding further buildings, including a chapel and a round hall, used for a time as a nursery. It is now owned by the archdiocese of Westminster.

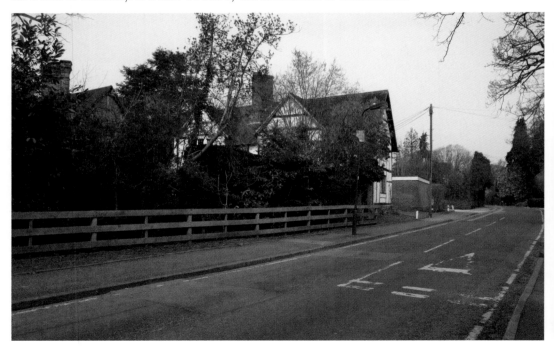

Gardens at Waxwell Farm and the Wax Well

A painting by Helen Allingham evokes the gardens of Waxwell Farm around 1900, when the gardens were created by Mrs Trotter. The name Waxwell is first recorded in the thirteenth century, though it has earlier origins. The well's brick canopy is Victorian. The well, and the pump just visible against the tree behind it in this Edwardian postcard, were fed by a spring until it was interrupted by sewerage works in 1902, to local regret as its waters had come to be regarded as having special properties.

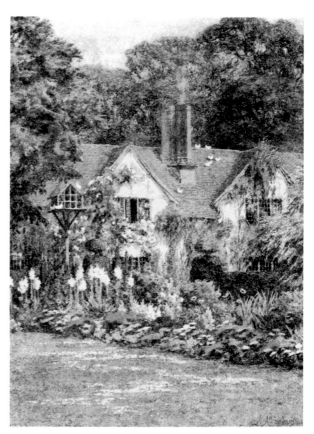

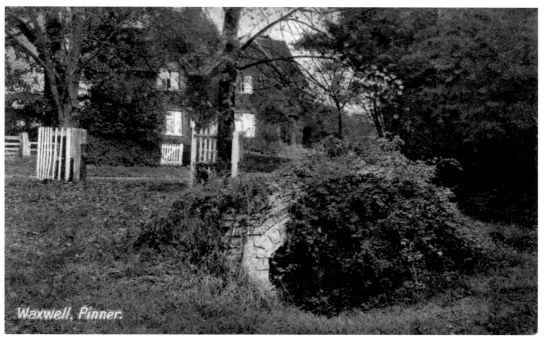

Waxwell, Pinner.

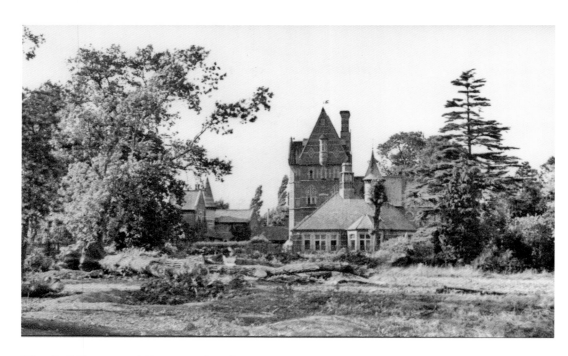

Woodhall Towers and Pinnerwood Park

Woodhall Towers, built in 1864 by Arthur Tooke, dominated the rise near historic Woodhall Farm until demolished in 1965. The view across the green in Woodhall Gate, from the west, has changed little since this photograph was taken in the early days of the Pinnerwood Park estate, begun 1933, although the trees have grown, and the towers and railings were removed in the Second World War. The white building, just visible at top right, is Woodhall Farm, the oldest building on the rise, now a private house.

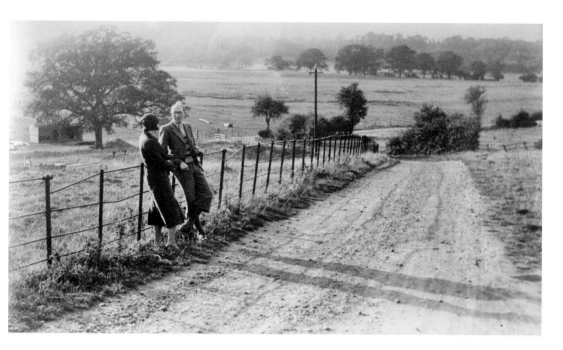

Woodhall Drive and Woodhall Gate, Pinnerwood Park
A last view of the fields of Woodhall Farm, before development, taken from approximately the point where Woodhall Drive curves out of sight in the postcard on the previous page; the green will be formed in the left background. The photographer, T. L. J. Bentley, seen here with his wife, lived in Woodhall Drive. Conservation Area status has helped preserve the appeal of the estate. A house in Woodhall Gate stood in for John Lennon's childhood home in the filming of the biopic *Nowhere Boy* in 2009.

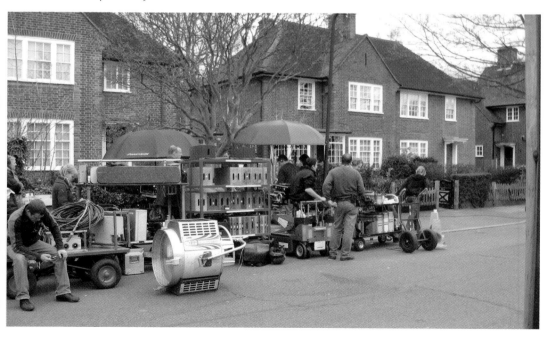

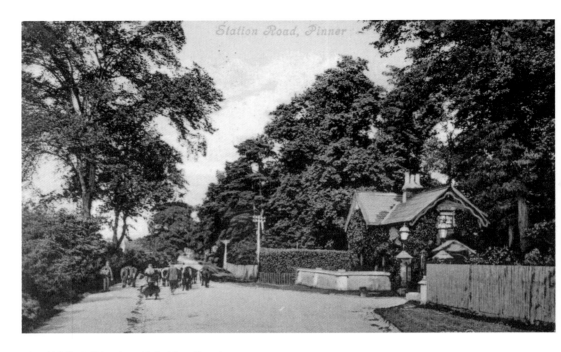

The (Old) Hall Lodge, Uxbridge Road

The lodge, subsequently extended, is the only obvious remnant of the Hall estate. The Uxbridge Road, called Station Road for a time, has long been one of the main through-routes in north Pinner. It was part of the road from Rickmansworth to Watling Street, and linked with many local routes to north and south. In the early days of motoring, there were sometimes speed traps here.

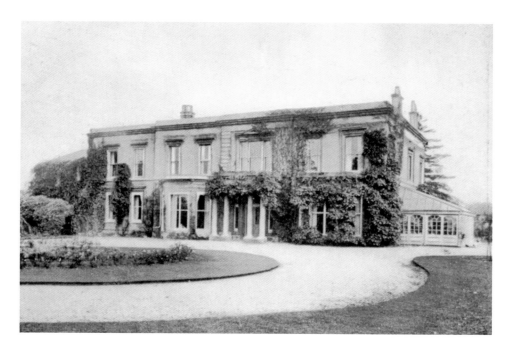

The Hall, Uxbridge Road

Now that only the lodge remains, it is hard to imagine how the early eighteenth-century Hall, remodelled around 1875, dominated this part of Pinner. The view below of the secondary entrance route from Paines Lane suggests the size of the estate, which stretched from Paines Lane at the west to Nugents Park, beyond St Thomas' Drive, at the east. In the early twentieth century, the grounds were often opened to local people for flower shows, or to visit the gardens or skate on its frozen lake.

Pinner Hall, The Asphalt Path

Coles Watford.

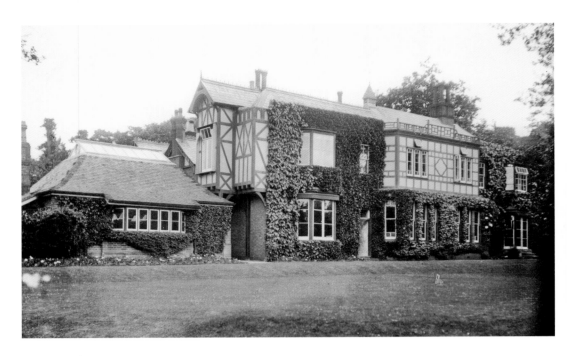

Barrow Point

Moss Lane Cottage below – the older, seventeenth-century part is weather-boarded – survives from a cluster of buildings at Bury Pond, later Barrow Point. The pond was down the hill by the Uxbridge road. The estate of Barrowpoint House, above, opposite the cottage, comprised much of the land from there to the village centre, and was sold for development after the death of its owner, William Barber. The house became St John's Preparatory School until badly damaged by fire in 1930. The school left the rebuilt house in 1970, and the site was redeveloped.

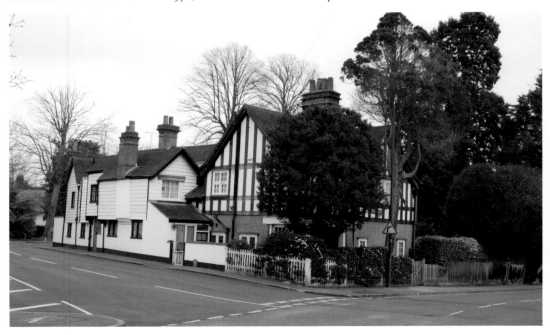

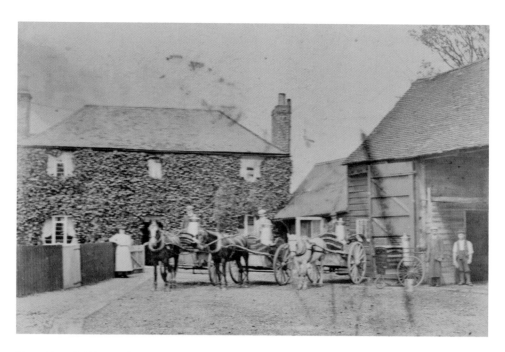

Near Woodridings Close, Hatch End

Woodridings Farm, which occupied approximately the site of today's Kol Chai Reform Synagogue, began in the eighteenth century. In the early twentieth century it supplied milk to local houses, some of them built on its former fields. Working horses were then a common sight. Nowadays, their appearance in Hatch End marks a special occasion, in this case the Diamond Jubilee of Queen Elizabeth II in June 2012.

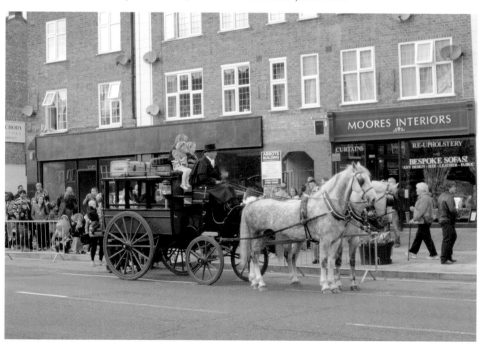

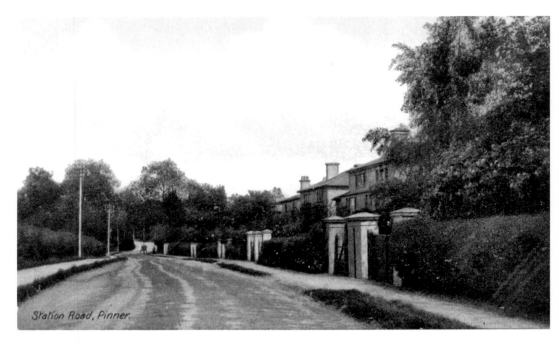

Station Road, Pinner.

Station Road/Uxbridge Road, Hatch End

This estate of 1855 was meant for users of the new railway. Designed to look grand, it was actually quite isolated for stay-at-home wives. Mrs Beeton lived in one of the houses off camera at the right and wrote her famous cookery book there. Now the road is so busy that it is usually hard to see for cars. On Sunday mornings, cycling enthusiasts take advantage of lighter traffic; these riders were taking part in the Hatch End Triathlon of 2013. Started in 2000 as a local event, it now attracts international competitors.

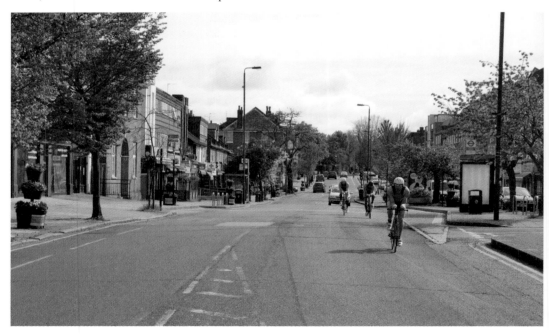

The Old Post Office, Hatch End

Around 1910, the post office (*left*), the Railway Hotel and a WHSmith's bookstall (right, behind trees) were the only businesses in this part of Hatch End. Some thirty years later, the post office was part of a much more recognisable Broadway. Though the buildings have changed little since, businesses are now very different. As late as 1970, you could do all routine shopping here, at Sainsbury's, WHSmith, Boots, Woolworths, MacFisheries, greengrocers, dress shops, etc. Now most premises are cafés or restaurants, and the Broadway can be liveliest at night.

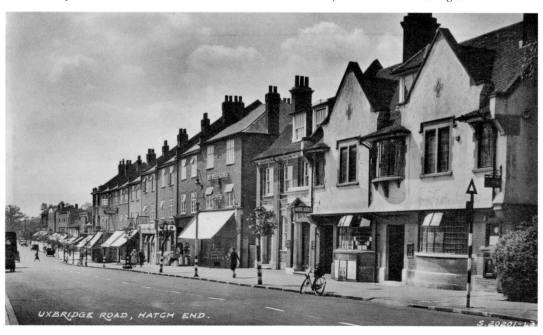

UXBRIDGE ROAD, HATCH END.

S.20201-L3

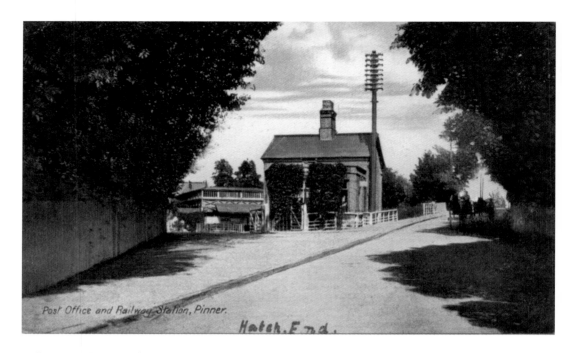

Post Office and Railway Station, Pinner.

Hatch End.

Railway Station, Hatch End

Hatch End (originally Pinner) station was among the first in London's environs. Its opening in 1842 by the London & Birmingham Railway Company heralded major changes for the area, though these progressed slowly. The foreground building above, where there are now only trees, was the stationmaster's house. The original station was at the back, low and unimpressive; the footbridge is seen above it. It was rebuilt in 1911 when the LNWR constructed the suburban lines. Main line services ended in 1963. Nowadays the station is part of the revitalised London Overground. The building is listed.

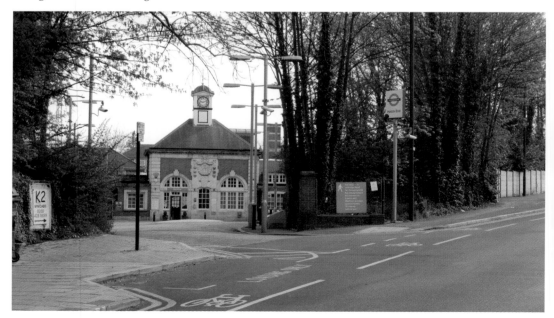

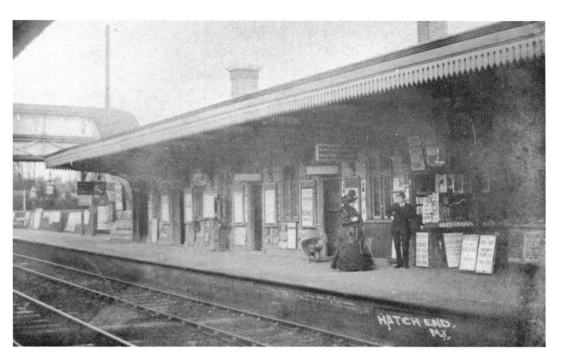

Nineteenth-Century Railway – the Platform and the Railway Hotel

Early travellers were often going to work in London. Pinner regulars included the Beetons, A. E. Housman (poet and professor of Latin at University College London), and Sir Frank Ree of Antoneys. The Railway Hotel opened around 1855 for the benefit of travellers and became a social centre for an area that for decades had few facilities. The oldest surviving building in the Broadway, it was demolished in 2004, despite its local listing, and replaced by a block of flats and a Tesco Express.

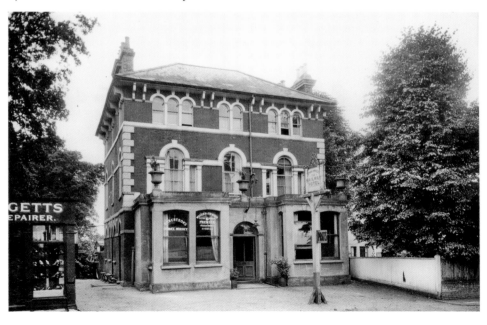

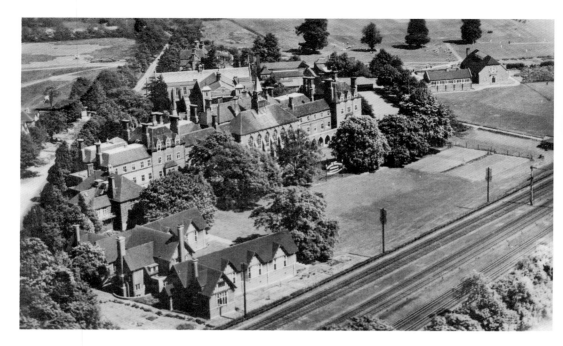

Royal Commercial Travellers' Schools, Harrow Arts Centre and Supermarket

The schools, for orphans of travelling sales representatives, came to Pinner in 1855, to inexpensive land near the new station. It was designed to impress railway travellers (potential donors). Later enlargements included the Elliott Hall, built in 1905, whose turrets are visible in the aerial view behind the main building. It is now the core of Harrow Arts Centre. After the school closed in 1967, the main building was demolished and the remainder became Harrow College of Further Education and, left foreground, St Theresa's Roman Catholic Primary School. Now Harrow Arts Centre has replaced the college and a supermarket has replaced the school.

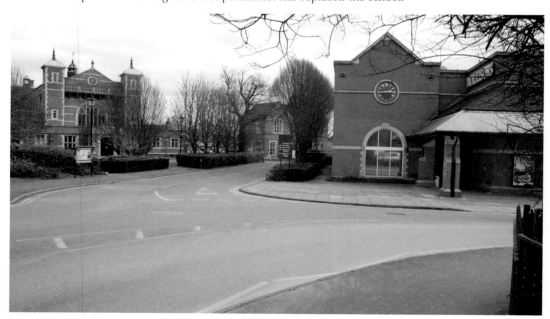

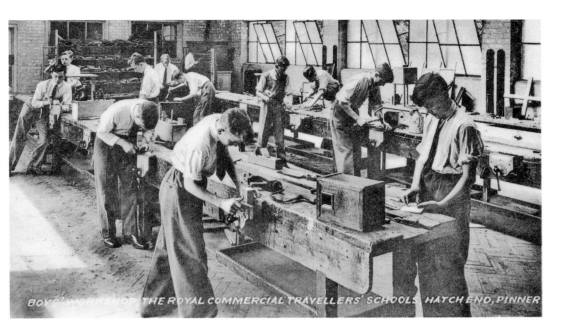

BOYS' WORKSHOP, THE ROYAL COMMERCIAL TRAVELLERS' SCHOOLS, HATCH END, PINNER

Boys' Workshop (now Rayners Room)

The schools' site is now a busy place. There are playing fields, a swimming pool, a gym, a library, the Elliott Hall itself and a small theatre used for music and drama, rooms used by local societies and for classes in art and physical activity, and even an apiary. This is apt as the schools had provided a balanced education, including learning, exercise, craft skills and agriculture. Art has long been part of Pinner life, with nineteenth- and twentieth-century residents including artists attracted by the rural surroundings.

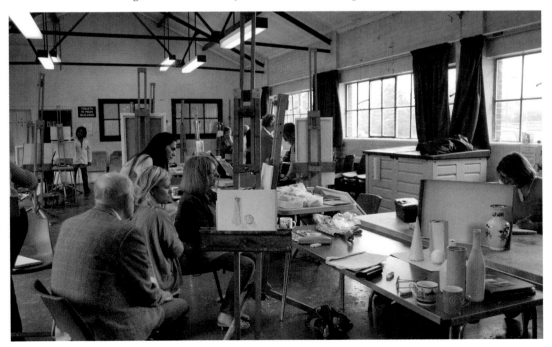

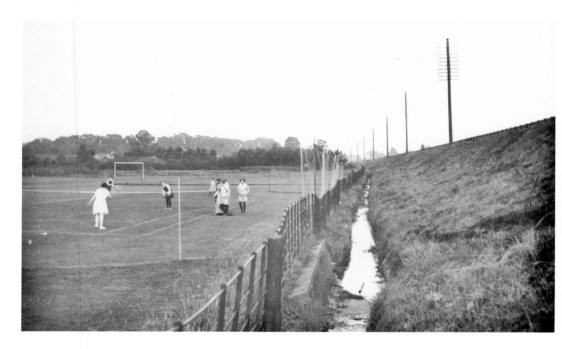

River Pinn by Railway, Behind Royal Commercial Travellers' Schools
In the nineteenth century, the Pinn was diverted to avoid the grounds of the Commercial Travellers' Schools – here are pupils in 1928 playing tennis. After this point, the Pinn travels west and south through the parish; in the late nineteenth and early twentieth century, it was often dammed to form ornamental features in the grounds of mansions like the Hall. It was reconfigured here in 2008 in the interests of flood prevention and wildlife – a rare, indisputable improvement! A little egret was recently spotted testing the waters.

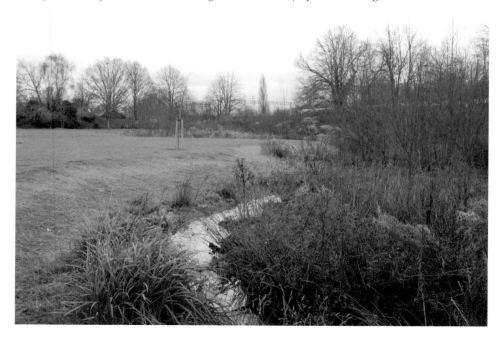

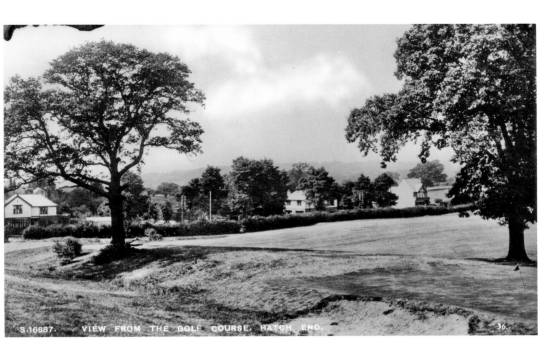

Grim's Dyke Golf Club

The oldest man-made structure in Pinner is Grim's Dyke, possibly an Iron Age boundary, visible here on the Grim's Dyke Golf Course, and also by the railway footbridge near Sylvia Avenue, in gardens near Hatch End Broadway between Altham Road and Woodridings Close, and in the Montesole playing fields. The club was founded in 1910 with neighbour Sir William S. Gilbert (of Gilbert & Sullivan fame) as its first president. Today's members continue to enjoy rural views near Old Redding in the club atmosphere.

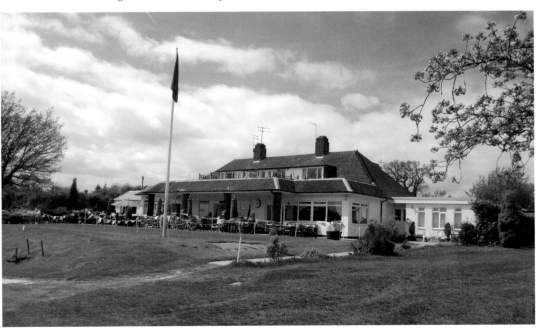

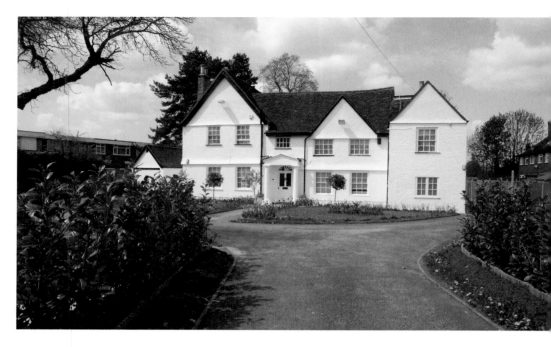

Letchford House and Letchford Arms

Letchford House, once Hatch End Farm, and built around 1600, is the only survivor from pre-railway Hatch End. To build its line, the London & Birmingham Railway Company was obliged to purchase the whole farm from Benjamin Weall in 1834; they used the house as the contractor's base. Around 1868, George Mold took over the reduced farm. He built the Letchford Arms, seen here in its heyday, and the cottages to either side. His son Alec was once described as 'one of the best hay farmers in Middlesex'.

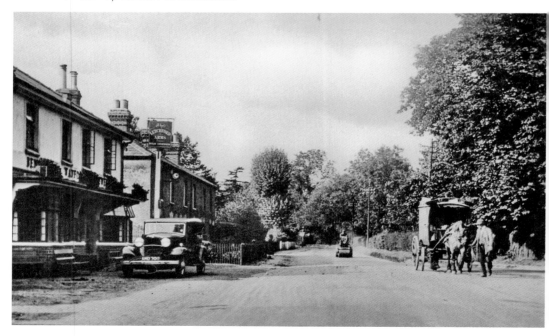

Headstone Lane: Letchford Terrace

At the Chantry triangle, seen here from the north, today's corner shop (below, behind the green tree) almost obscures the surviving early twentieth-century cottages, and the pump, trough and stone are long gone. The wider angle below also reveals the Letchford Arms, in a sorry state in April 2013, and part of George Mold's Letchford Terrace, present but unseen at the time of the earlier picture. The carts were probably going to the goods yard; several local people were in the transport business.

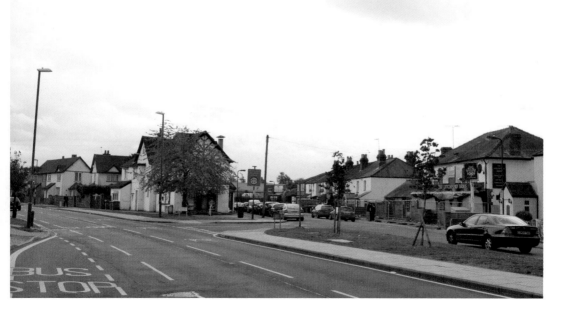

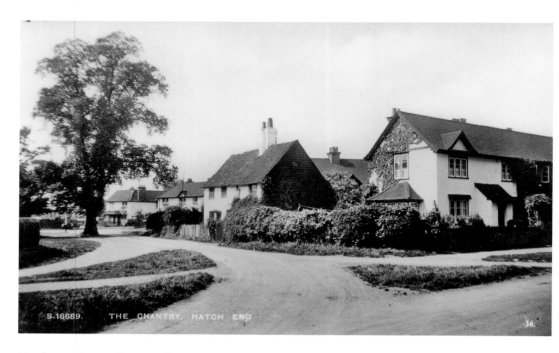

Headstone Lane: Chantry Place

The little seventeenth-century cottage on the south side of the Chantry triangle, above, was demolished in the 1950s; its newer neighbours remain. It had been part of the original tiny hamlet of Hatch End, beyond the gate (hatch) of the Archbishop's deer park at Pinner Park. The nearby Railway Cottages, below, lasted till the 1970s. In 1911, when the local line was constructed, all held railway workers, mostly navvies; one four-room house held a navvy, his wife and six children, and five unrelated navvies, the most severe overcrowding in Pinner.

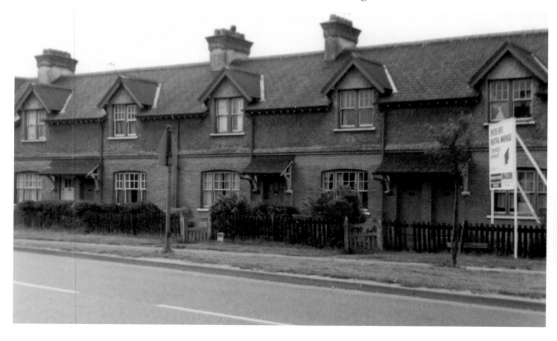

Headstone Lane Near Rail Bridge

This substation supplied electricity for the local service; Bakerloo line trains served Headstone Lane and Hatch End stations from 1917 to 1982. It was constructed on a part of Hatch End Farm retained by the railway company for a goods yard. Today, the substation has been replaced by a commercial building, while storage units have been built on the site of the railway cottages (*see p. 80*), and a small industrial park has replaced the sidings behind them.

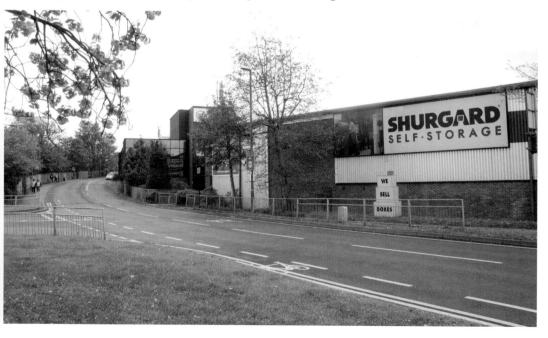

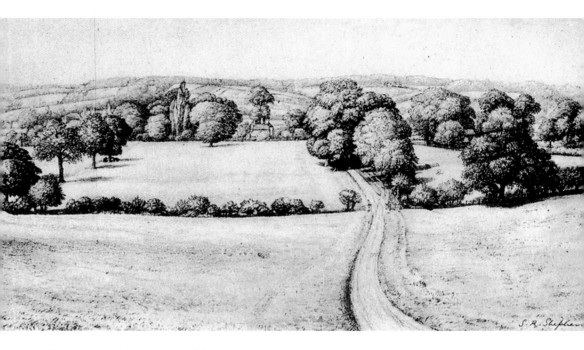

Pinner Park, from Nower Hill

A deer park of 250 acres, surrounded by a bank and a double ditch, was first mentioned in 1273. In 1927, this little changed, although the deer had long been replaced by farmland. Pinner Park Farm is just visible left of the old track across the park. In 1930, plans to develop the park for housing were frustrated when a farsighted Hendon RDC scheduled it as an open space. Nevertheless, a dual carriageway, George V Avenue (seen here about 1938), was soon to cut the ancient park and track in two.

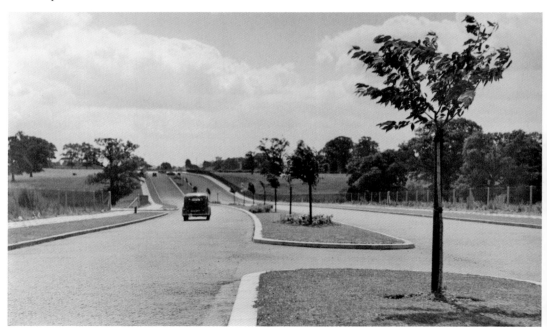

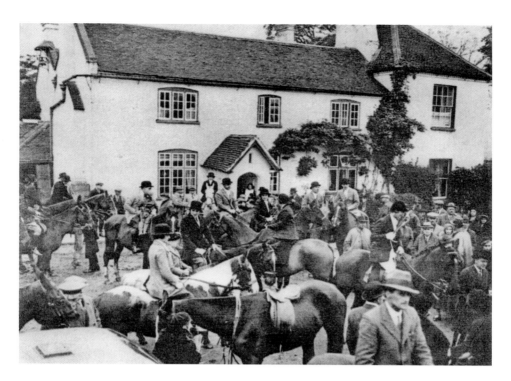

Pinner Park Farm

Pinner Park farmhouse was built around 1753. A map of 1634 shows that an earlier house on the site was surrounded by a moat. The Middlesex Farmers' Hunt held their opening meet here in 1932/33. Today, this is still a working farm of over 200 acres – something of a surprise in a London borough.

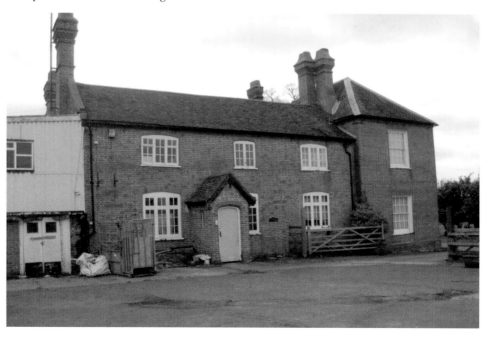

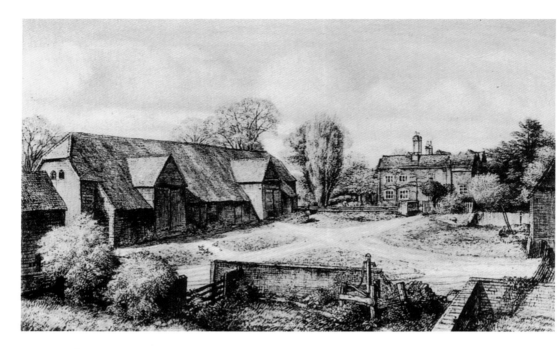

Headstone Manor

John Stratford, the Archbishop of Canterbury, purchased Headstone Manor in 1344. Parts of that building survive, making it the oldest surviving timber-framed dwelling house in Middlesex. The Manor was a working farm of some 200 acres, but much of it was sold for housing and only sixty-three were left in 1925, when it was acquired by Harrow Council. It is now a park. The etching above was made not long after farming activities had ceased. The Great Barn on the left was built in 1506, and is currently Harrow Museum and Heritage Centre.

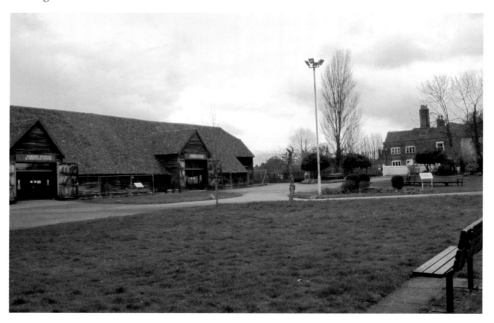

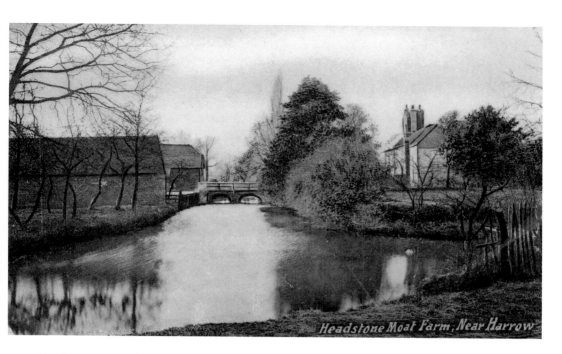

Headstone Moat Farm, Near Harrow

Headstone Manor's Moat

Headstone Manor is surrounded on all sides by a moat. In the medieval period, a moat symbolised a building's high status. The picture above is a tinted postcard, which was posted in 1907 when the manor was known as Moat Farm. Today, that moat is still complete, and filled from a nearby spring. It is the only complete and water-filled moat to survive in Middlesex.

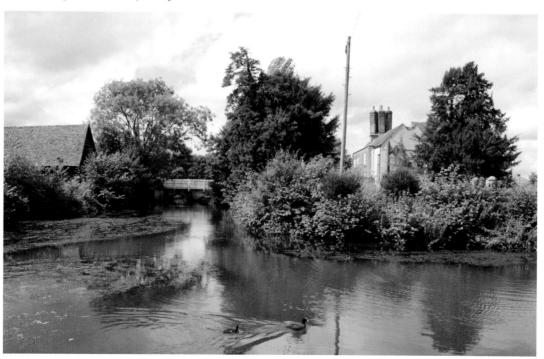

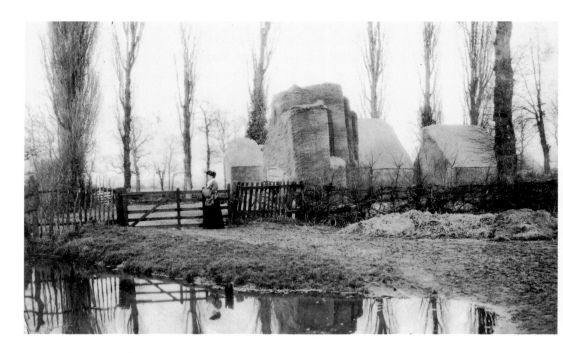

From Haystacks to Houses

For centuries, the fields of Headstone Manor had been producing the hay needed to feed London's horses; no doubt these haystacks beside the moat at Headstone Manor in 1906 were destined for London. But in the 1920s, as horses were being replaced by motor vehicles, Headstone's hayfields were beginning to be put to another use. This haystack may have been one of the last, before the fields were built over. Two semi-detached houses in Woodberry Avenue, North Harrow, nearly completed, can be seen in the background.

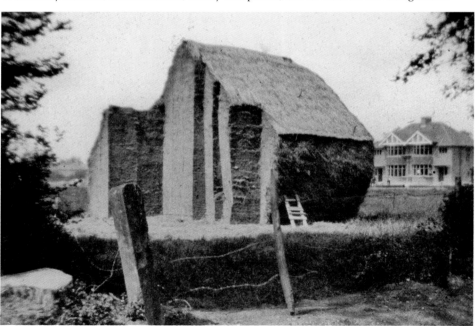

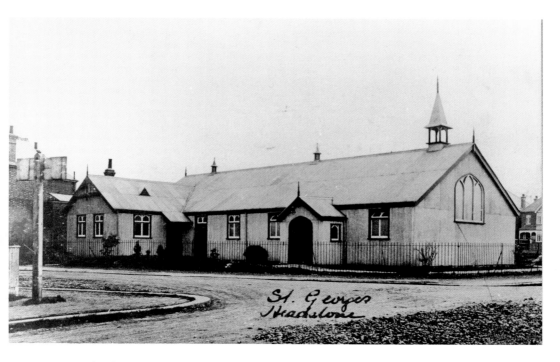

St George's Church, Headstone

In the early 1900s, the population of Headstone was rapidly increasing, and a new church was needed to serve these new residents. In 1907, a corrugated iron church was erected in Pinner View as a temporary measure. In 1911, it was replaced by this rather more substantial building.

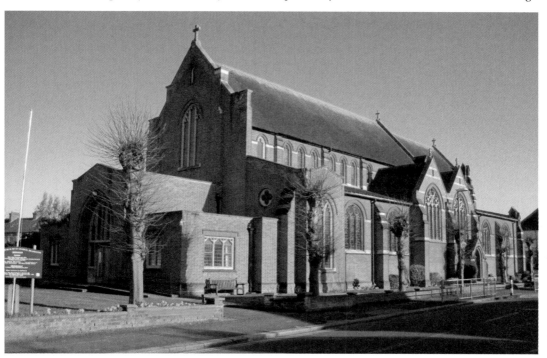

The March of Time

In 1924, Pinner artist Stanley Shepherd, then only eighteen years old, drew this picture of the development of the road to the recently-opened station in North Harrow. Contrasting the ancient elm trees with the new buildings, he entitled it 'The March of Time'. Later that year, it was exhibited in the Royal Academy Summer Exhibition.

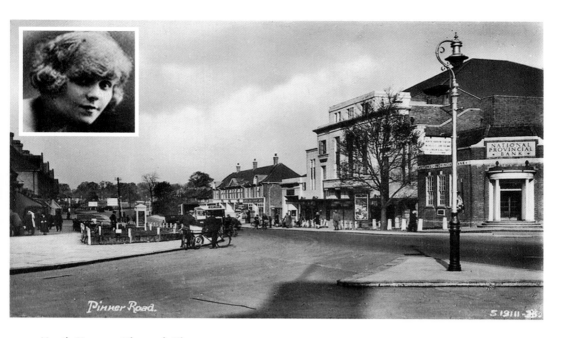

North Harrow, Through Time

The imposing building on the right was the Embassy Cinema in the Broadway, North Harrow, opened in 1929 by the English film star Betty Balfour (*inset*). In 1963, it was replaced by a supermarket, and in 2012 this, in its turn, was replaced by a gym with flats above it. The flowerbeds and the phone kiosk on the left are no longer there; and the National Provincial Bank building on the right is now an estate agent's.

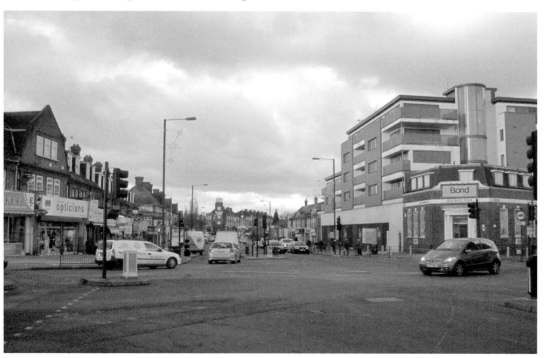

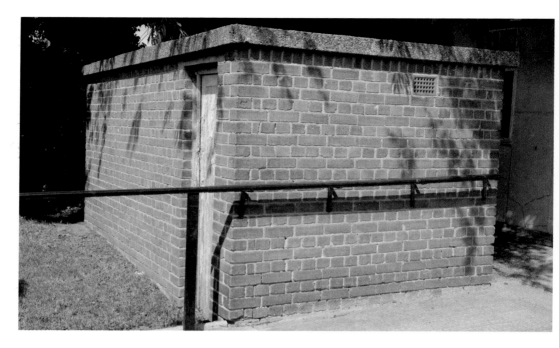

The Second World War

This is an ARP warden's post in North Harrow. Forty-two of them were built in the Pinner area following the outbreak of war in 1939. Each had its own telephone and was manned by volunteers, twenty-four hours a day, throughout the war. This is Post No. 21, the only one to have survived. The white building below, which adjoins it, was a British restaurant – one of several in the area, and the only survivor. It was built in 1944 to replace the previous one on this site, which had been destroyed by a flying bomb on June 30th 1944. But the warden's post, just visible on the extreme left, survived the bombing virtually undamaged.

Pinner Village Gardens
Pinner's parks are often
known only to those
who live nearby, though
increasingly valuable as
more of us live in flats.
Several parks contain traces
of the past, among them
Montesole Playing Fields at
Pinner Green, where in the
woodland outskirts are both
Grim's Dyke and the sealed
entrance to one of Pinner's
chalk mines. Here in Pinner
Village Gardens and in
nearby Yeading Walk, the
keen eye can make out the
ridge-and-furrow of Pinner's
medieval open fields.

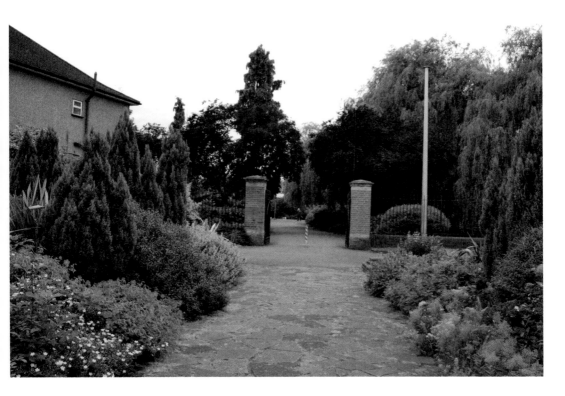

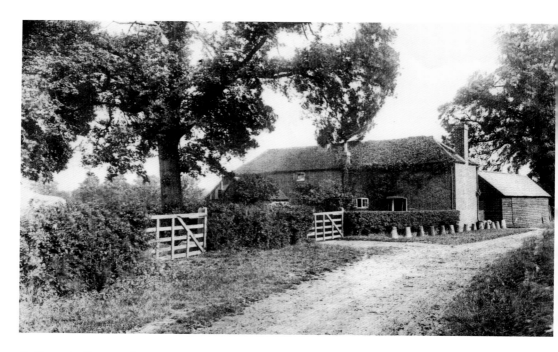

Cottages in Rayners Lane, *c.* 1910

Running between the common fields, this lane had been the route from Pinner to Roxeth (South Harrow) since medieval times. The Rayner family were farmworkers employed by Daniel Hill, who farmed much of the land either side of it. For many years up to the 1870s, they lived in these early nineteenth-century tied cottages along what came to be known as Rayner's Lane. When the land was developed, Farm Avenue was laid out across the front of the cottages and Atholl School (now Buckingham College) and the Quaker meeting rooms filled the rest of the site.

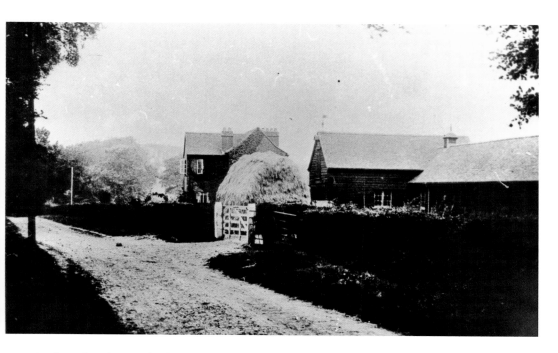

Lankers Brook Farm in the 1920s

One of the last farms to be built, Lankers Brook Farm dates from 1915. Its land formerly belonged to Church Farm. The first development north of Village Way was Harrow Garden Village, influenced by the garden village movement. It featured closes clustered around small greens and retained many grand old oaks and elms. The farmhouse has become an ordinary suburban house (No. 552) with post-war properties filling the old farmyard. Below, it is seen across one of the greens, with Rayners Lane continuing towards Pinner in the background.

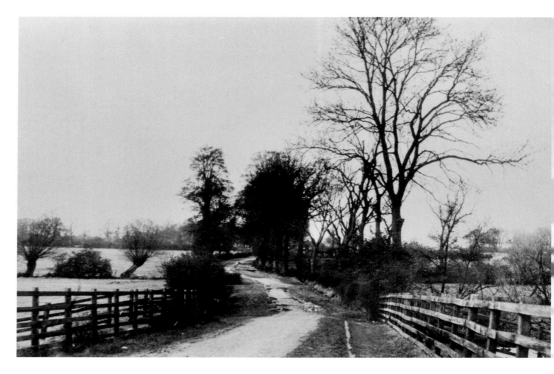

Rayners Lane

The view above was taken around 1920 from above what is now the junction with Village Way, looking towards Pinner. The view below was taken from just beyond the further trees, but looking towards the new station at the top of the hill around 1935. Traces of the ancient lane can still be seen in the elm trees. They were killed by Dutch Elm disease in the 1970s, but some old oak trees still survive in other parts of the lane.

Zoroastrian Centre

The plaque affixed to this building by Harrow Heritage Trust reads, 'This Art Deco cinema building was designed in 1936 by F. E. Bromige and built by T. F. Nash Ltd.' At first it was the Grosvenor, then in 1938 the Odeon, in 1950 the Gaumont, in 1964 the Odeon and in 1981 the Ace. From 1990 it was a bar, the Cine Bar Experience. It was acquired by the Zoroastrian Trust Funds of Europe in 2000. It was restored and refurbished into a Zoroastrian Community Centre and place of worship and is its European Centre. This part of Rayners Lane is now a conservation area.

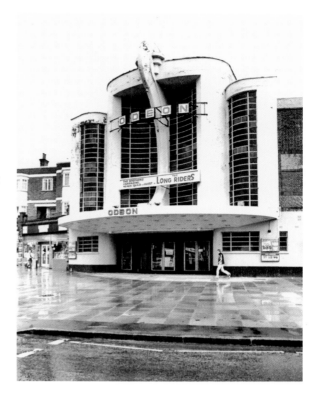

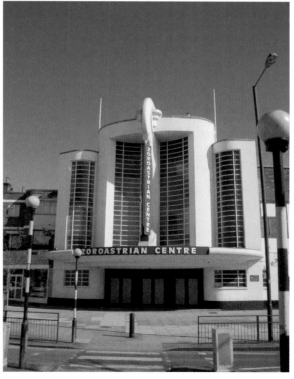

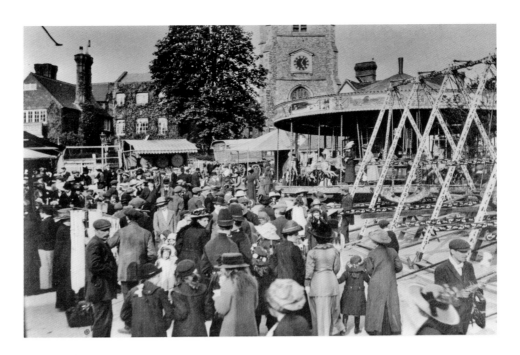

Pinner Fair

Pinner Fair, granted by royal charter in 1336, takes over the streets once a year. Originally it was a trade fair, but by the 1830s it was more like a village sports day, accompanied by much fun. Steam-powered rides, freak shows and stalls of all sorts dominated by the late nineteenth century, marred by occasional disorder. Since at least 1829 some have wanted the fair abolished, as being rowdy and disruptive, but locals have generally supported it, and recently, despite terrifying rides, it has been quieter. There are concerns about its viability, but it is to be hoped that it will continue for centuries yet.

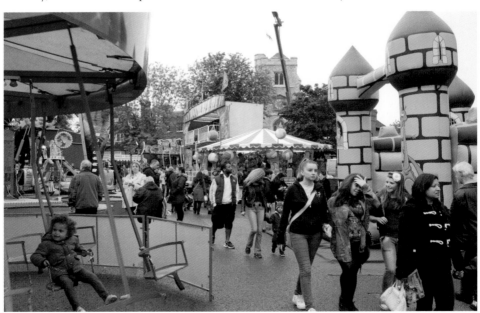